20 WAYS to DRAW EVERYTHING

With Over 100 Different Themes

Including Sea Creatures, Doodle Shapes, and
Ways to Get from Here to There

Featuring the illustrations of Trina Dalziel, James Gulliver Hancock, and Rachael Taylor

chartwell
books

CONTENTS

Introduction4
How to Use This Book5

GET UP AND GO

Bikes6
Antique Autos8
Strollers................10
Shoes12
Pairs of Skis............14
Sailboats16
Trains..................18
Hot-Air Balloons20
Motorboats22
Tricycles24
Dump Trucks26
Biplanes28
Rickshaws30
Jet Skis32
Motorcycles............34
Submarines............36
Semitrucks38
Rocket Ships40
Unicycles42
Four-Wheelers..........44
Helicopters46
Motor Scooters........48
Taxis...................50
Jets and Airplanes.....52
Magic Carpets.........54
Tractors56

Roller Skates58
Surfboards.............60
Buses62
Bulldozers64
Limousines66
Racing Cars............68
Ocean Liners70
Canoes72
Fire Engines74
Skateboards76

UNDER THE SEA

Jellyfish78
Puffer Fish.............80
Rays82
Anemones84
Seahorses86
Squid..................88
Starfish90
Walruses92
Whales94
Angelfish..............96
Clown Fish.............98
Crabs.................100
Crocodiles102
Dolphins104
Lionfish106
Narwhals..............108
Octopi................110
Seals112

Sea Serpents...........114
Sharks.................116
Seashells.............118
Sponges...............120
Sea Turtles 122
Mermaids.............124
Corals126
Fishermen 128
Hermit Crabs........ 130
Sand Dollars..........132
Scallops............. 134
Sea Urchins 136
Clams 138
Manatees140
Oysters...............142
Swordfish 144
Sea Slugs............146
King Neptunes 148

OODLES OF DOODLES

Flowers150
Stars152
Clouds154
Exclamation
Points156
Cylinders158
Arrows160
Tornadoes162
Leaves164
Zigzags166

Fish Tails168
Rainbows170
Snakes172
Houses174
Flourishes...........176
Hearts178
Spirals180
Fleur-de-lis182
Crosshatches184
Cones186
Scallops188
Loops190
Banners192
Squares194
Vines196
Lightning Bolts198
Cubes200
Waves202
Flames204
Teardrops206
Tentacles208
Peace Signs210
Trees212
Diamonds214
Doodles216
Planets & Comets....218
Question Marks220
Anchors............222

INTRODUCTION

Get ready to learn how to draw truly everything! Over 100 diverse and exciting themes await you in the pages that follow, showing you how simple abstract shapes and forms create the building blocks of anything that you could want to draw. This sketchbook is organized into three sections—"Get Up and Go," "Under the Sea," and "Oodles of Doodles"—featuring creative versions of hundreds of iconic subjects.

Designed to help you observe, see, and draw in a fun and interactive way, "Get Up and Go" explores different ways to travel, from bikes and boats to scooters and surfboards. You'll be challenged to look at the varied lines, marks, and shapes that bring these items to life, and give you ideas on how to approach your own drawings. Imagine all the fabulous adventures you could have while strolling, flying, or skating around. The idea of mechanics and movement come into play as you begin to make drawings in this book.

The ocean covers more than two thirds of the world. There are thousands of different types of animals living in it and new creatures are still being discovered. "Under the Sea" asks you to imagine the myriad of ways those creatures down in the deep could appear. The best way to learn to draw something is by studying it in real life, so draw on your experiences of scuba diving or visiting an aquarium if you have them. If not, your imagination runs as deep as the ocean, so dive in!

The word *doodle* refers to a simplistic interpretation of an image, however, you will see that any simple theme can be conveyed in many innovative ways. "Oodles of Doodles" is the perfect area to experiment with various approaches to drawing and sketching. Doodles can be created from memory, or drawn directly from observing an object or referring to a photograph. They can be accurate, representative, or abstract; these pages are crammed with inspirational goodness to help you doodle in new ways and develop new types of marks.

If you are nervous about drawing, just think of it as mark making. That is all you are doing—making marks on a surface. Sometimes your creations will look like something specific, and sometimes they won't; it is all good. Absorb all the inspiration, hints, and tips, and get ready to draw anything and everything!

HOW TO USE THIS BOOK

There are over 100 drawing prompts in this book and each one contains twenty examples, all drawn in a different way. Some are simple, while others are more detailed. Some are accurately drawn using a realistic scale, while others are abstract and suggestive. Some drawings use textures, pattern, or shading, while other are light and delicate. Some spreads may have all of the drawings on one page leaving the other page free for you to fill with your own drawings. Some pages have spaces in between to add your own drawings.

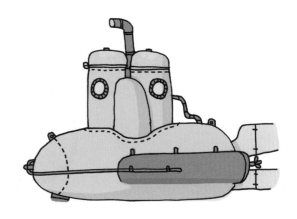

Start by drawing things you know, items you see every day. Look at these drawings for ideas, or draw those you imagine in your head. It may seem a little challenging to find twenty different ways to draw anything, but when you break it down to the different parts and shapes, it all becomes fun and interesting. If you approach drawing in this analytical way it will become second nature. Don't feel you have to stop at twenty either. Carry on for as long as you like!

As you work through this book, feel free to use a variety of media and assess how you really see things. Your drawings can be made using any media including ink, pen, pencil, watercolor, acrylic, or even a combination of these. Each method will have its own unique result: A fine pen will naturally bring delicate details, whereas acrylic paint will bring a more-textured outcome.

In addition to line, texture, and shape, be sure to think about scale, while you draw. This can produce some stunning results. Don't miss the subtle details, the not-so-obvious views, and the simple shapes. All of these observations will help you to create fascinating drawings.

There are no right or wrong approaches and no mistakes. One drawing leads to the next, and each step strengthens your creative muscles. Some drawings will naturally be more successful than others, but it doesn't mean the others are not good. Always keep your drawings so you can reflect on them at a later date and incorporate the textures or mark making into other pieces of work. The only rule is to have fun!

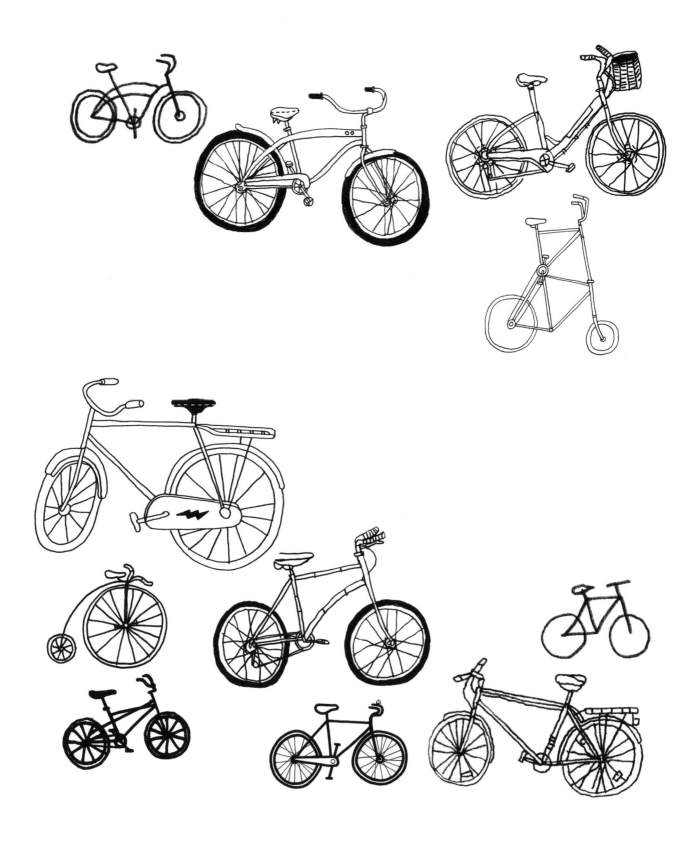

DRAW 20
Bikes

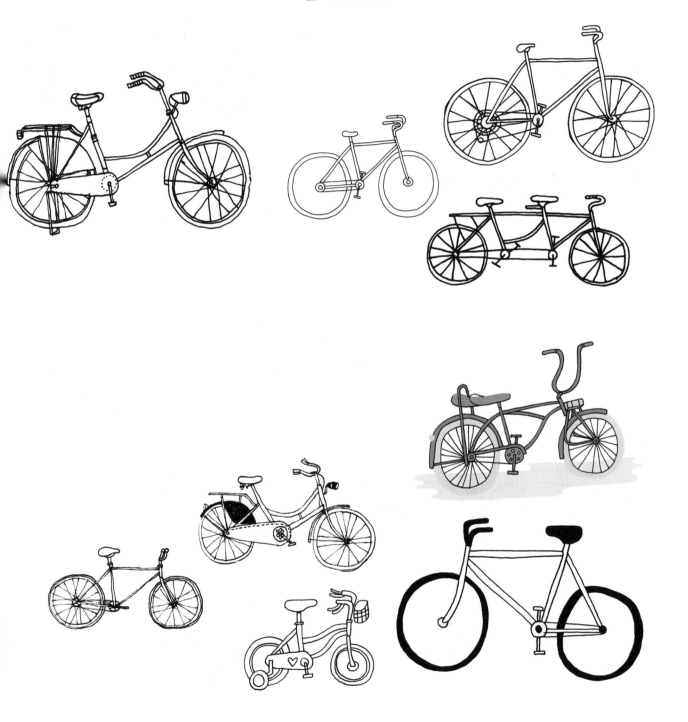

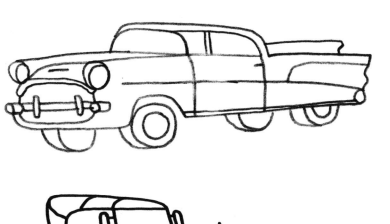

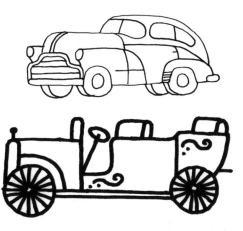

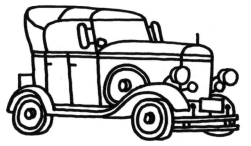

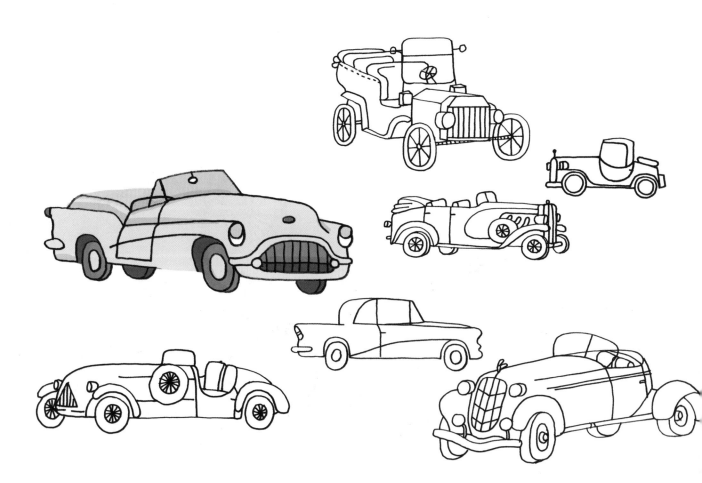

DRAW 20
ANTIQUE AUTOS

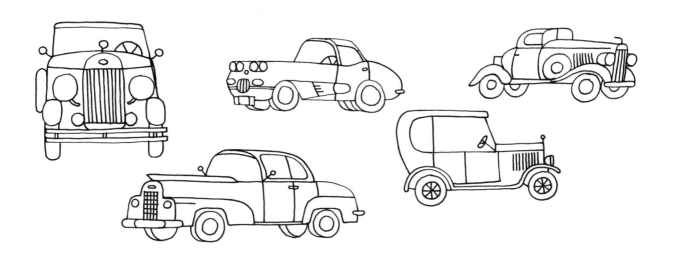

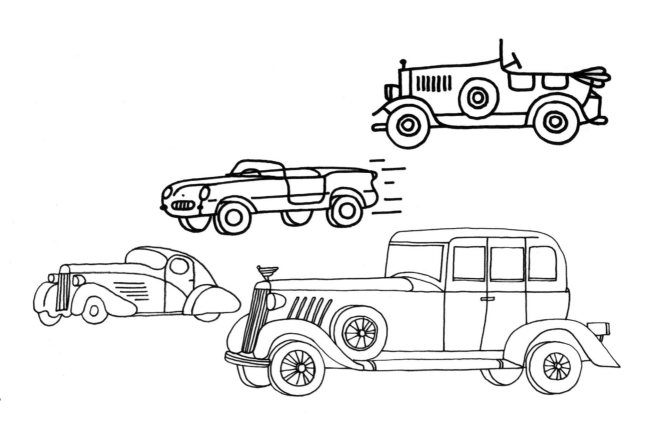

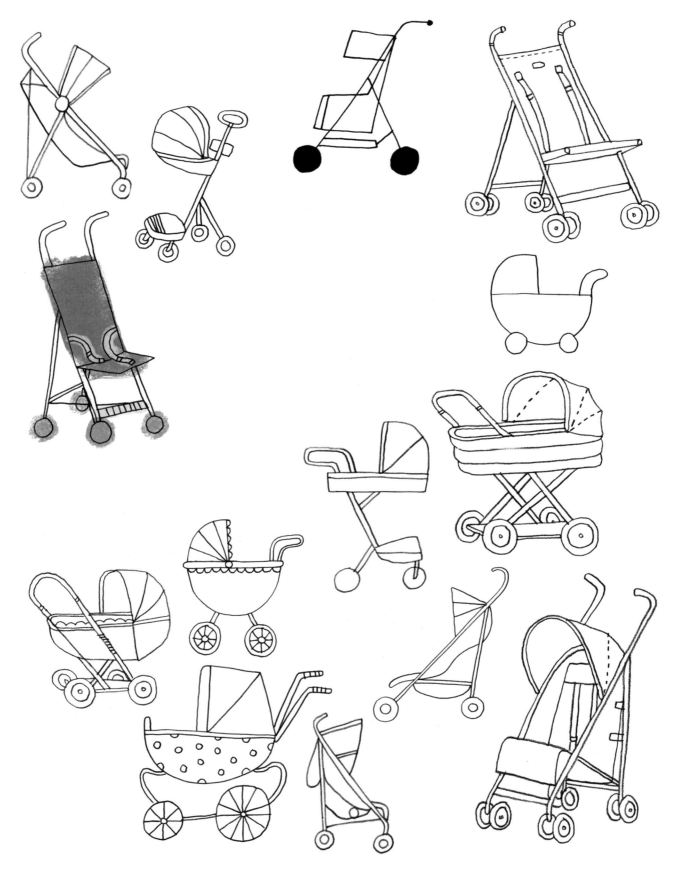

DRAW 20
STROLLERS

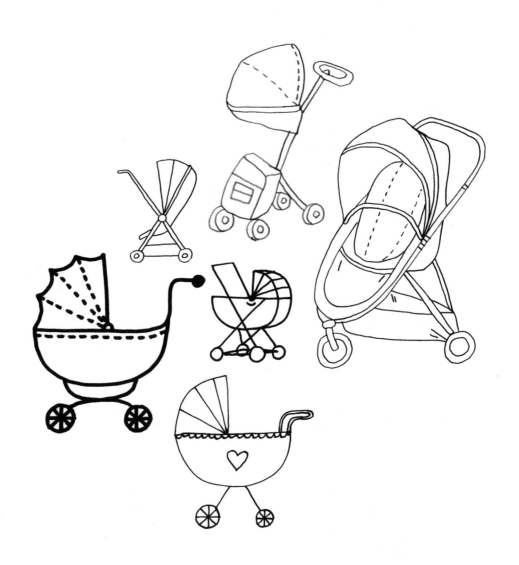

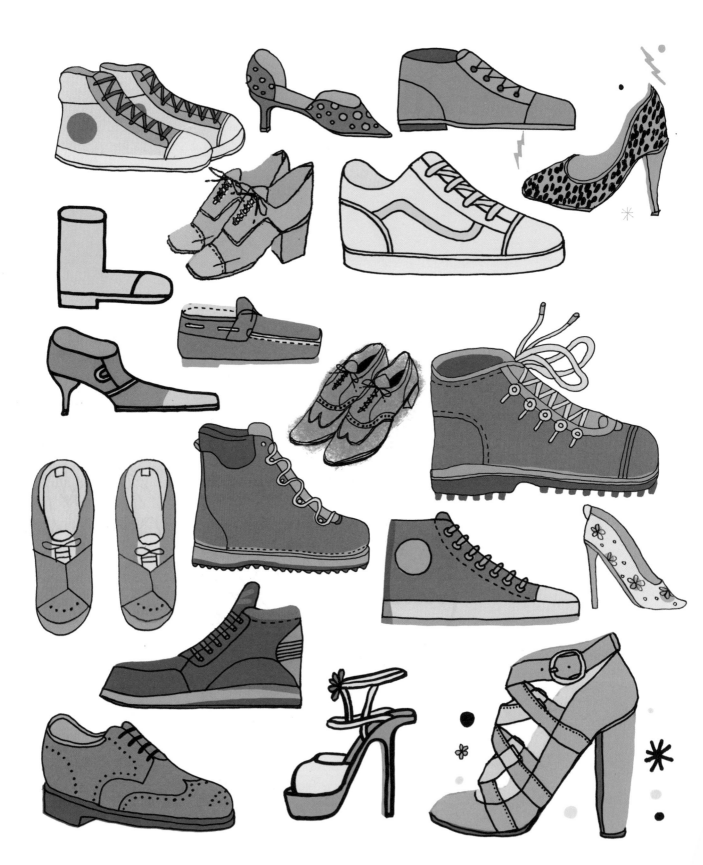

DRAW 20
SHOES

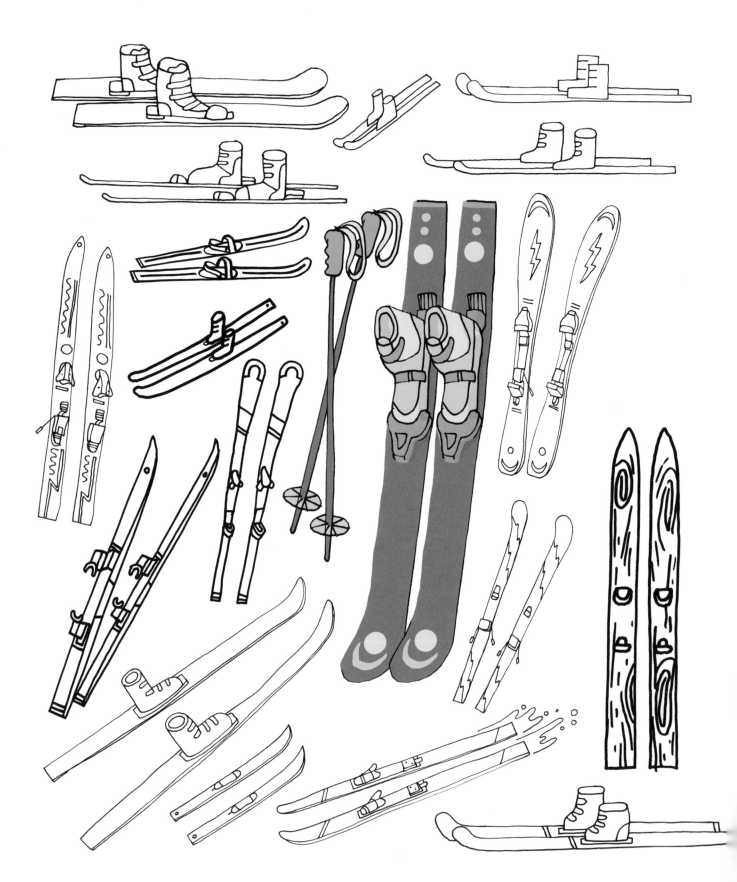

DRAW 20
PAIRS OF SKIS

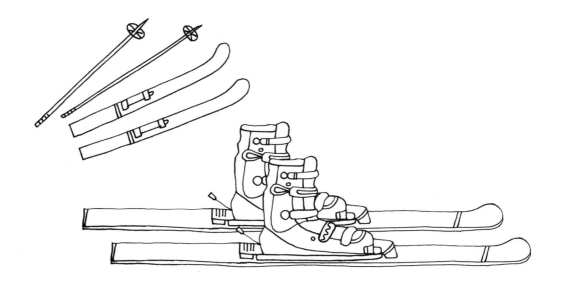

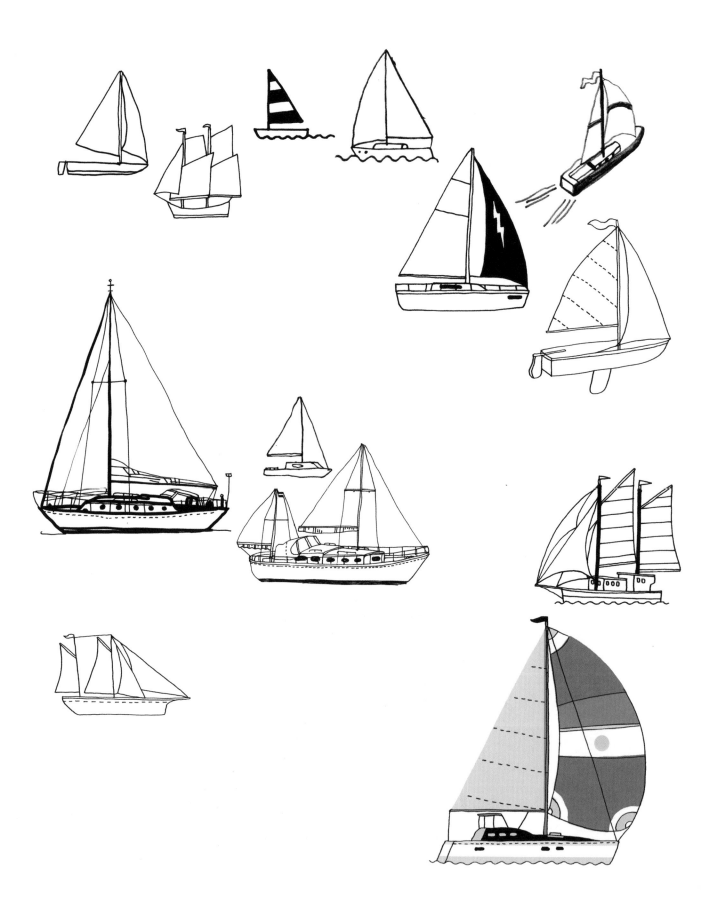

Sailboats

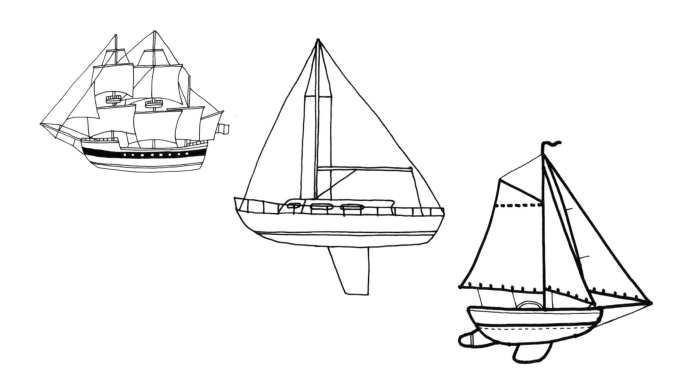

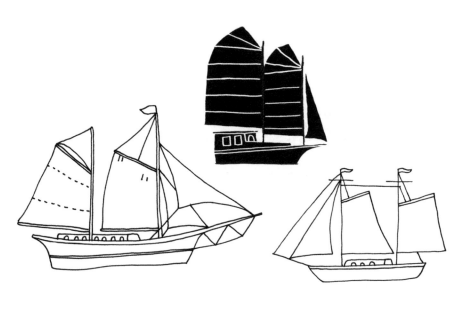

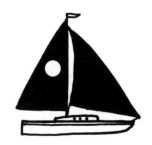

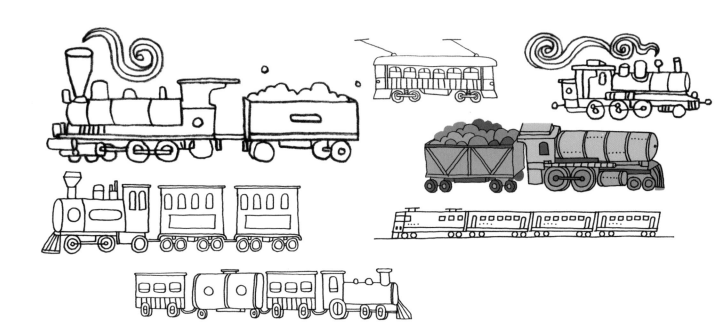
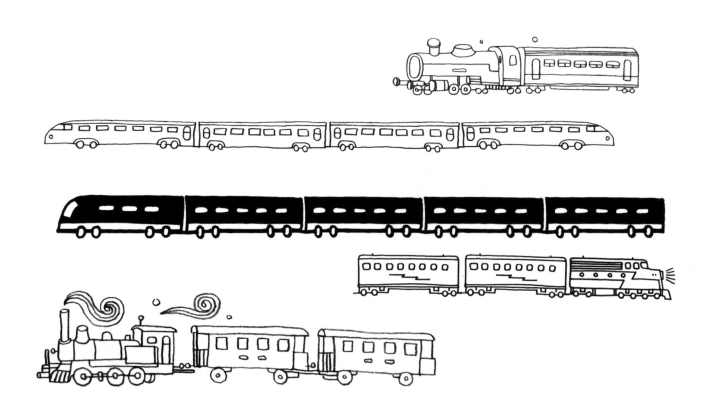

DRAW 20
TRAINS

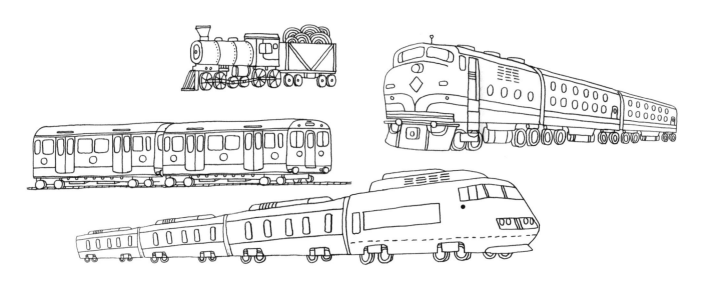

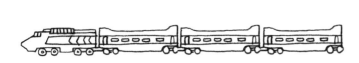

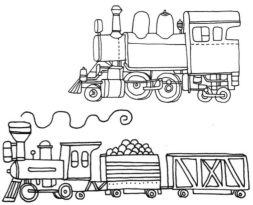

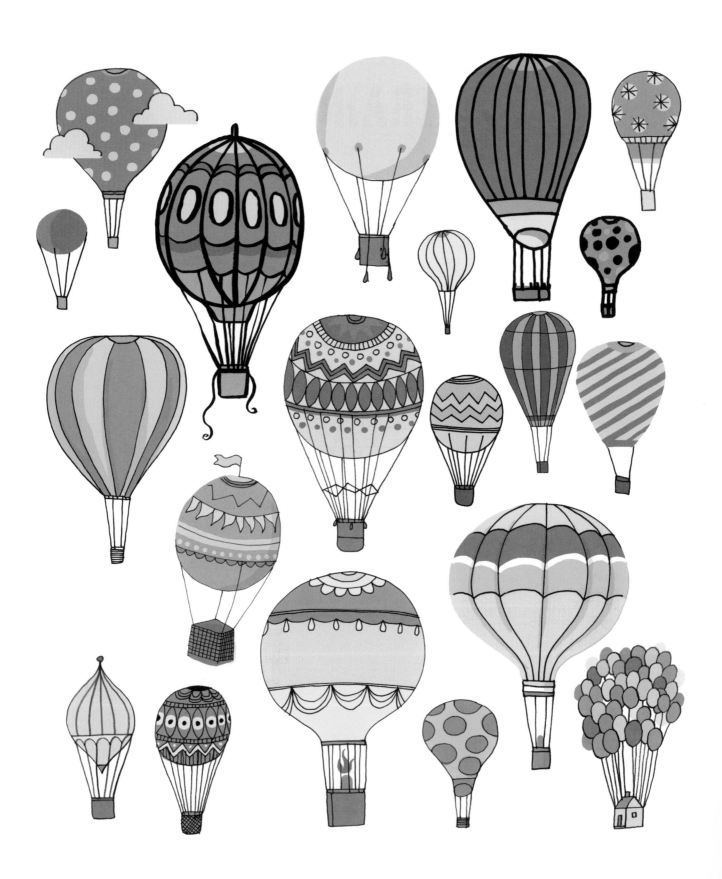

DRAW 20
HOT-AIR BALLOONS

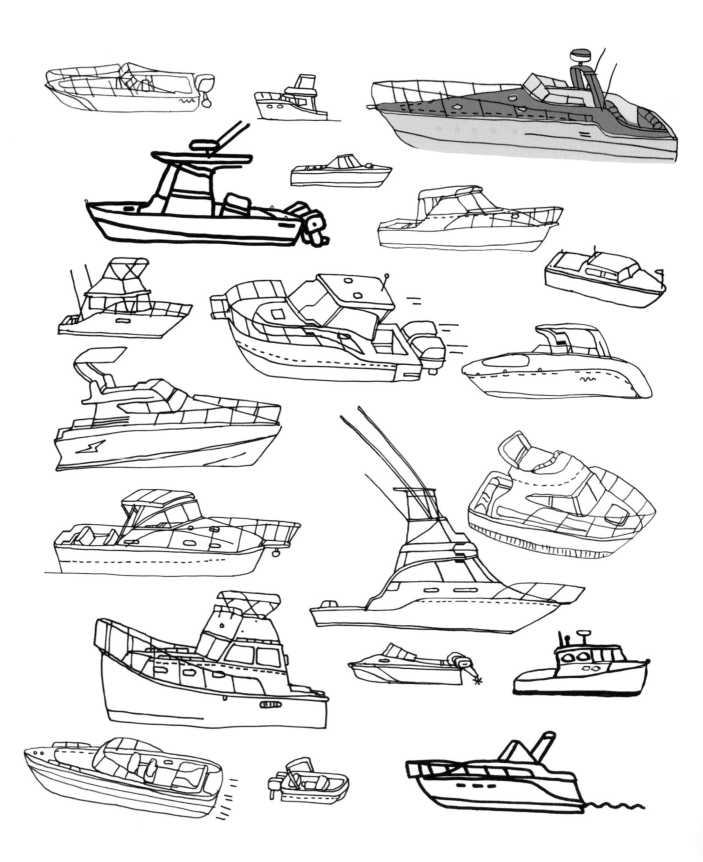

DRAW 20
MOTORBOATS

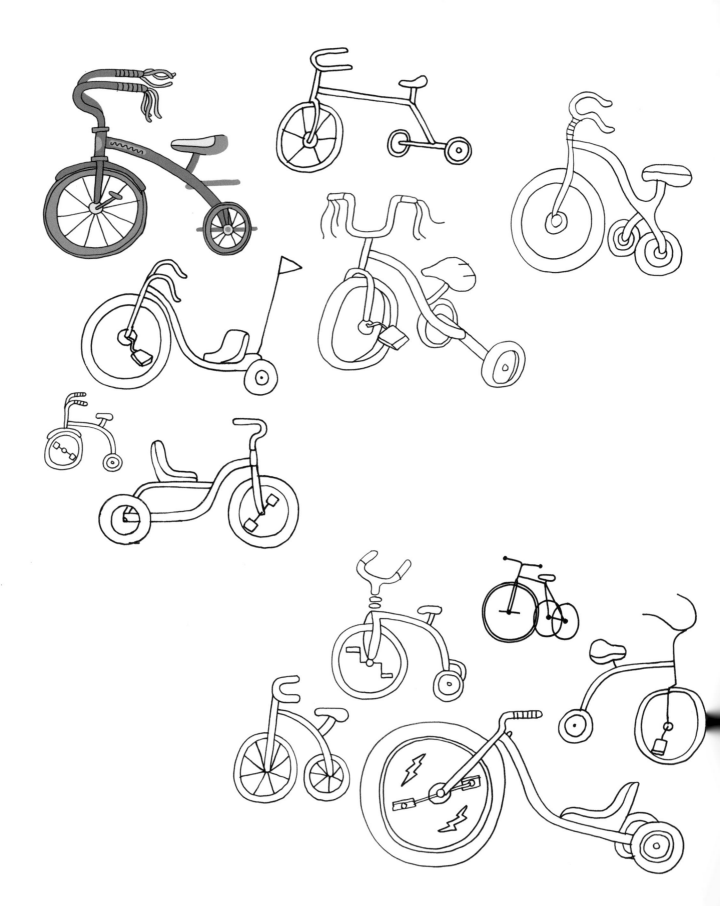

TRICYCLES

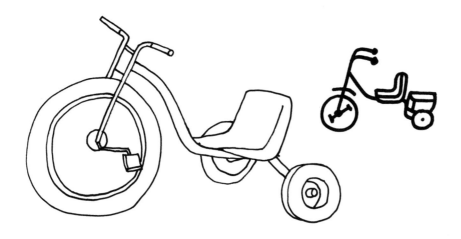

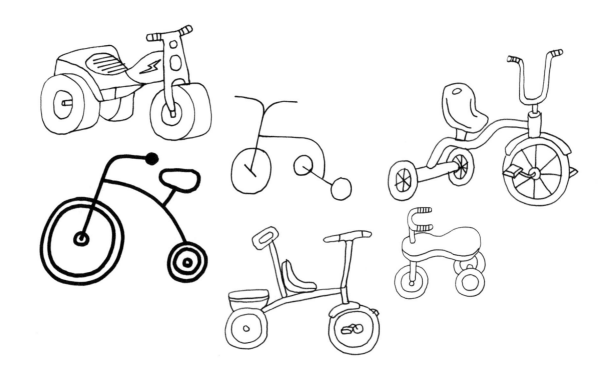

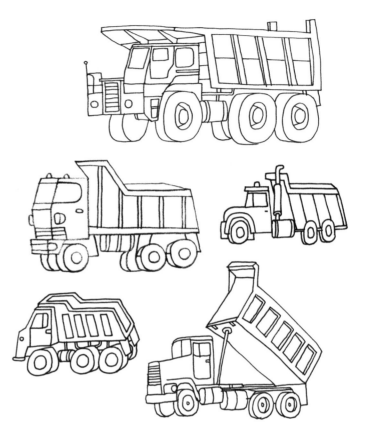

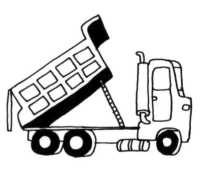

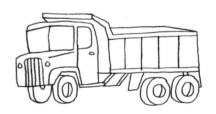

DRAW 20
DUMP TRUCKS

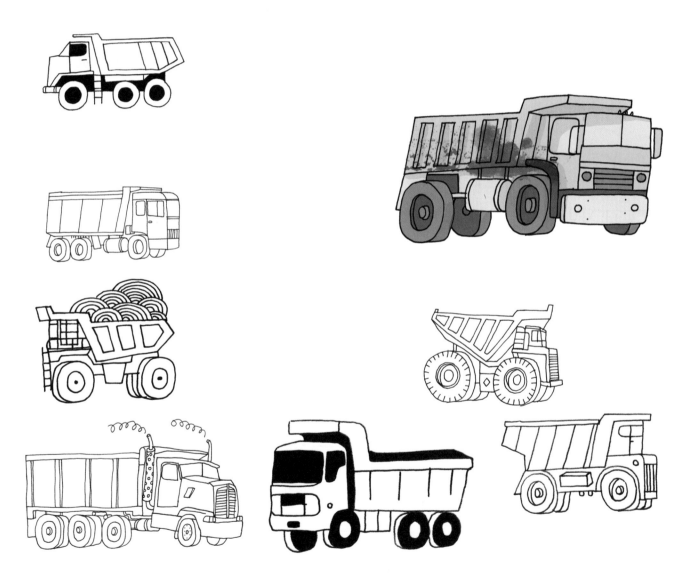

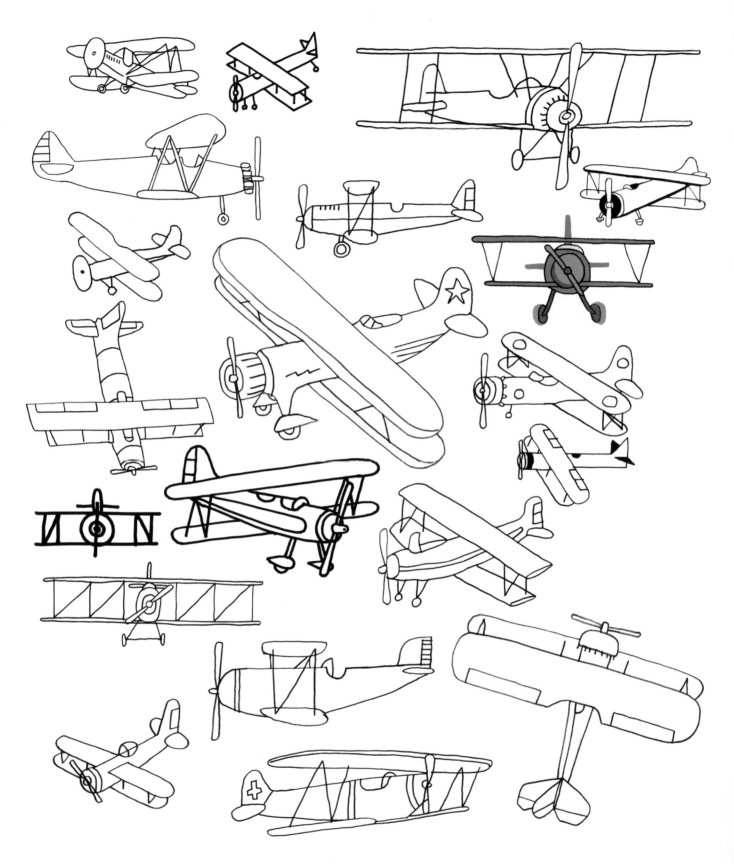

DRAW 20
BIPLANES

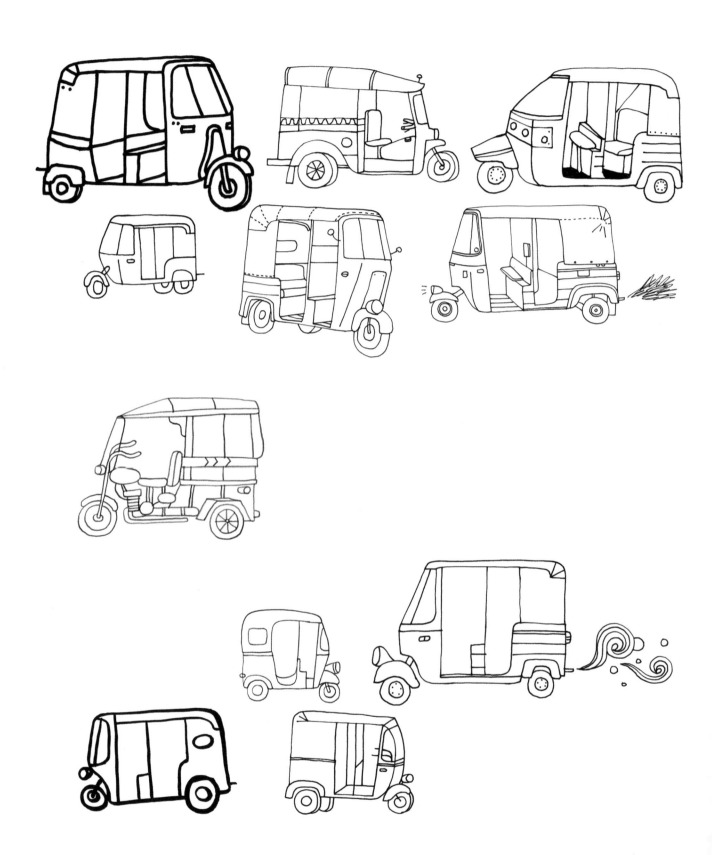

DRAW 20
RICKSHAWS

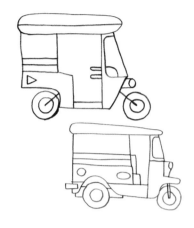

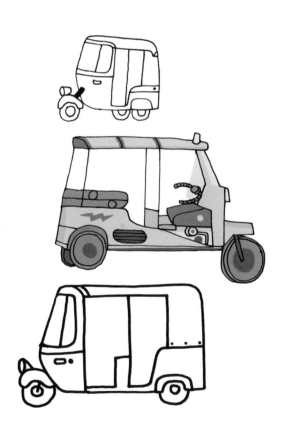

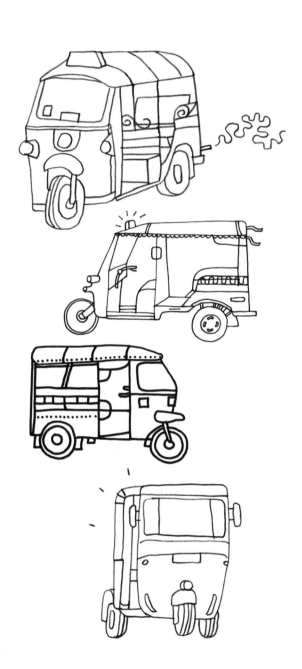

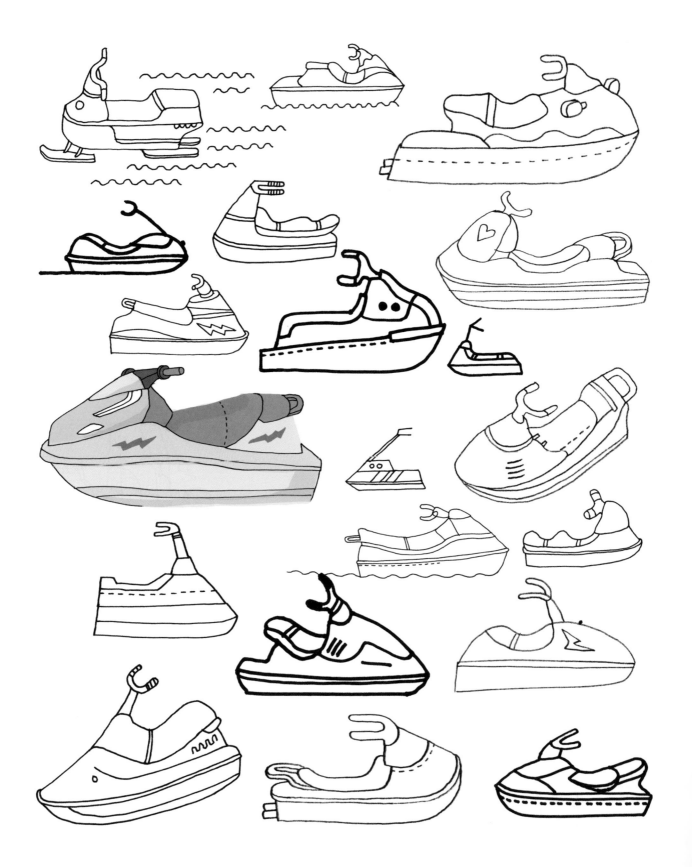

DRAW 20
JET SKIS

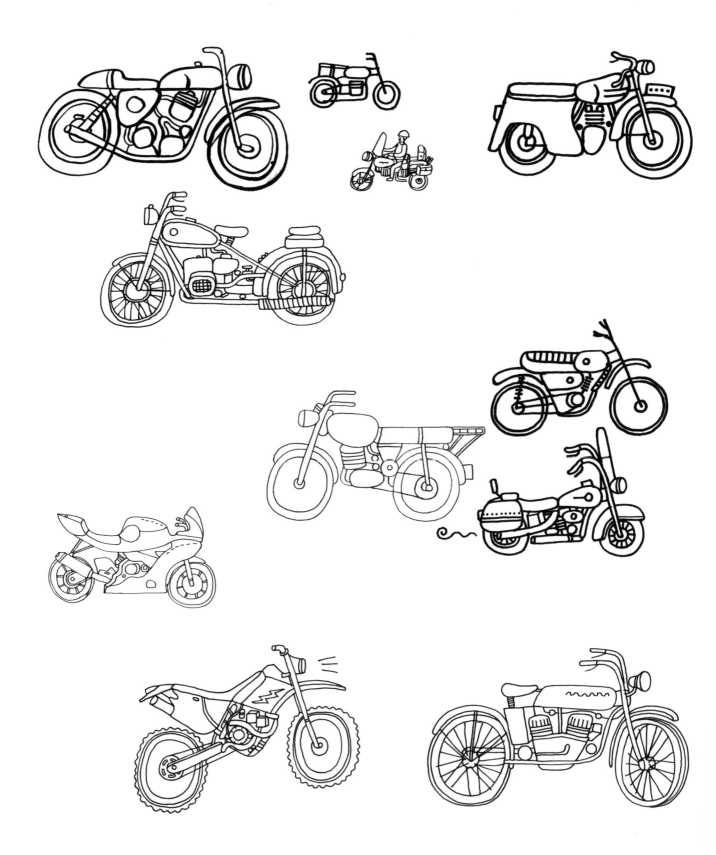

DRAW 20
Motorcycles

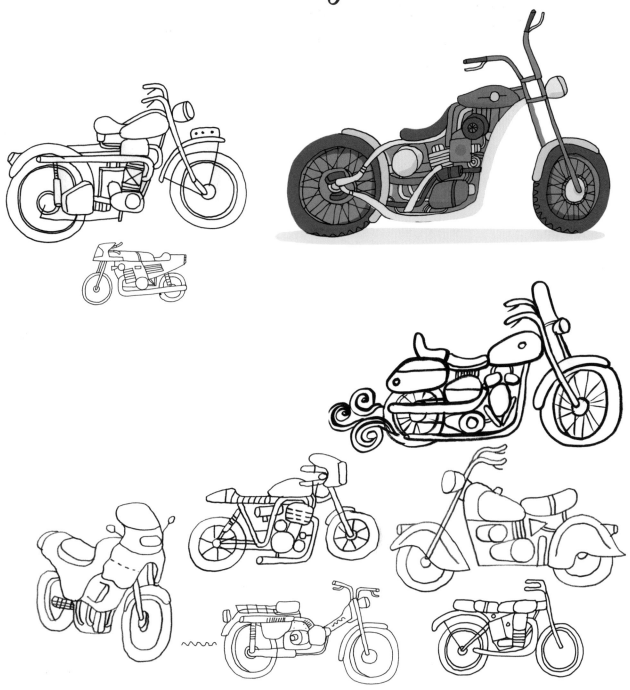

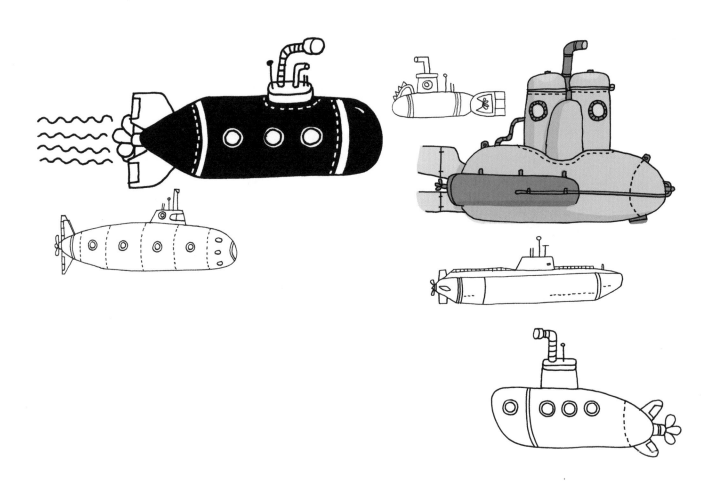
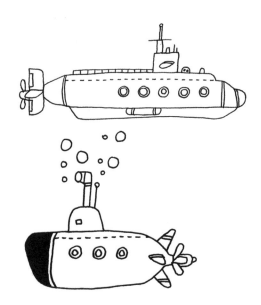
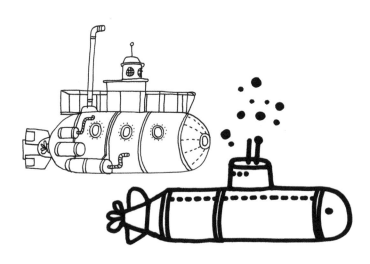

DRAW 20
Submarines

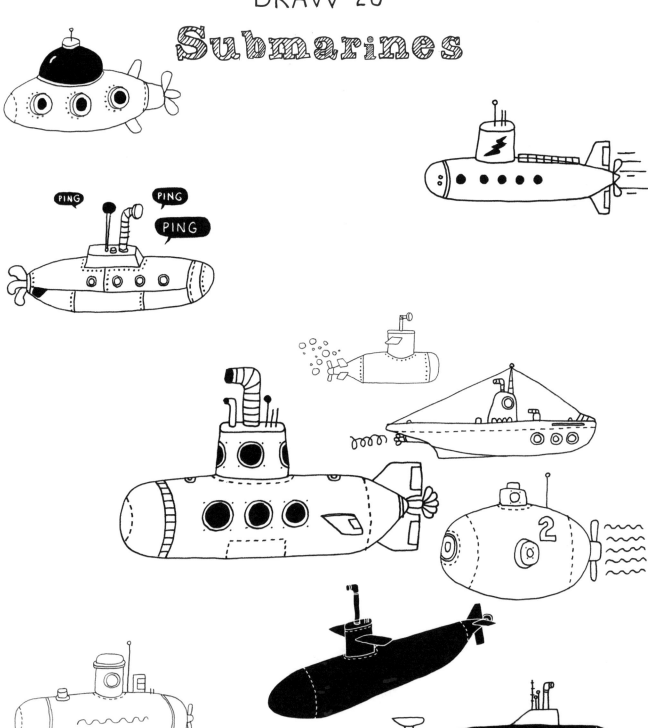

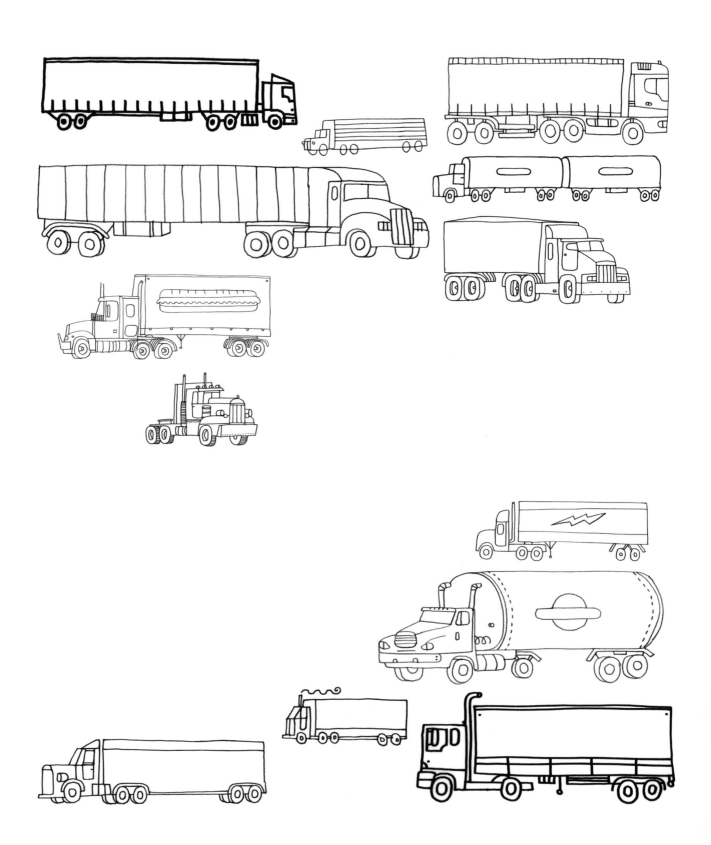

DRAW 20
SEMITRUCKS

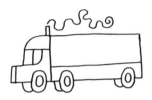

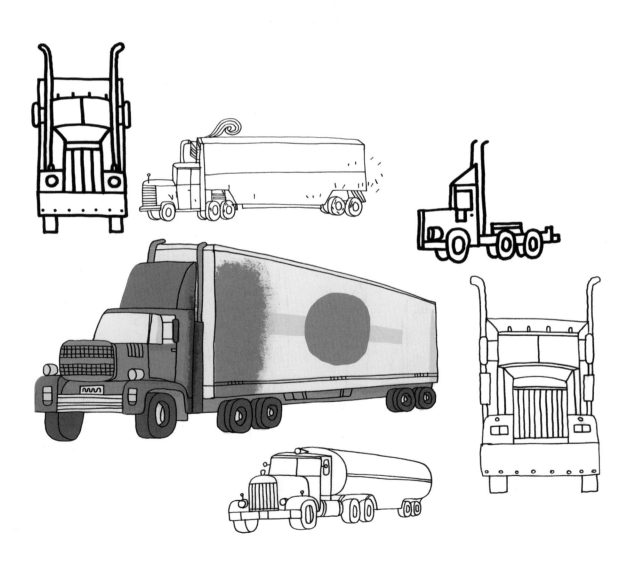

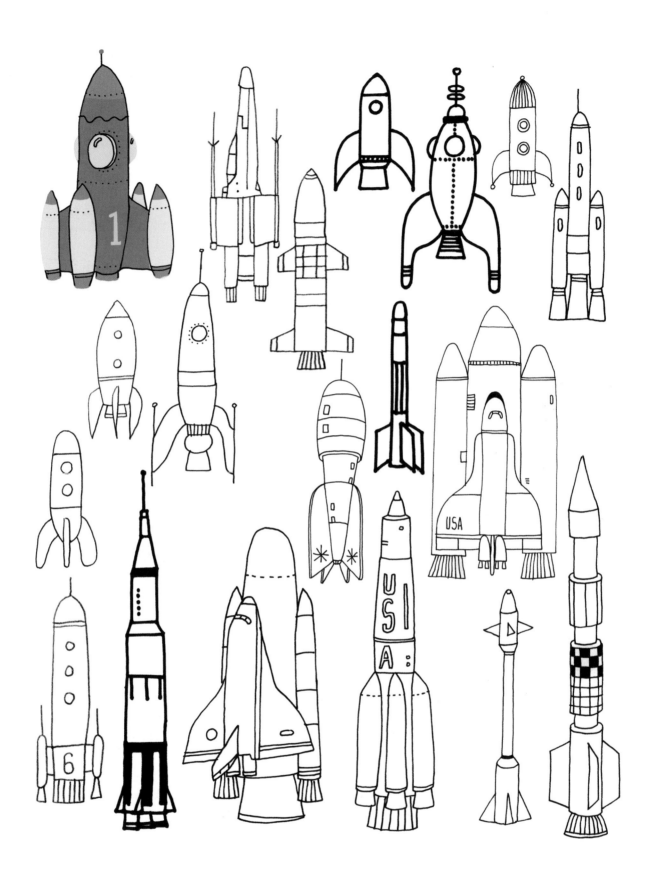

DRAW 20
ROCKET SHIPS

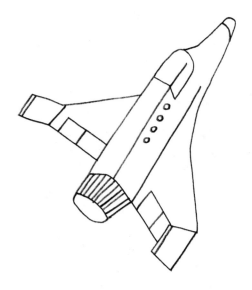

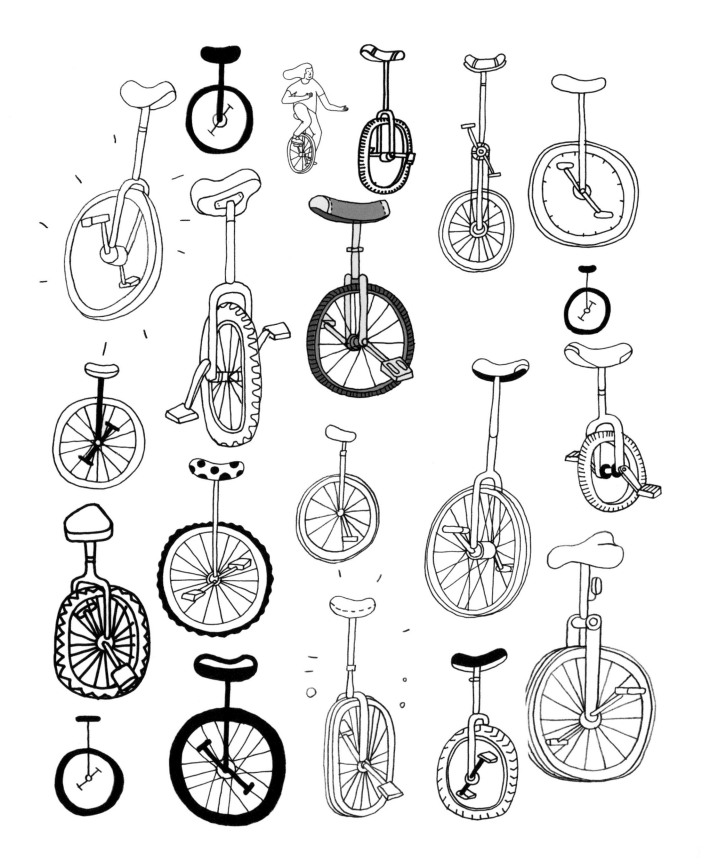

DRAW 20
Unicycles

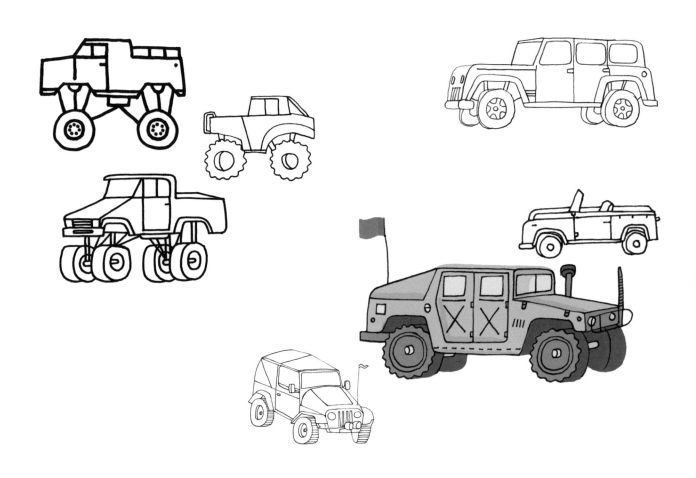

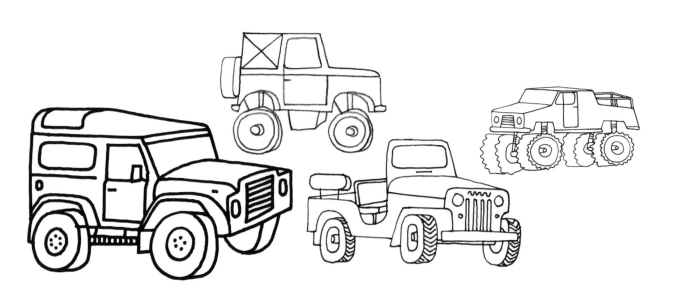

DRAW 20
FOUR-WHEELERS

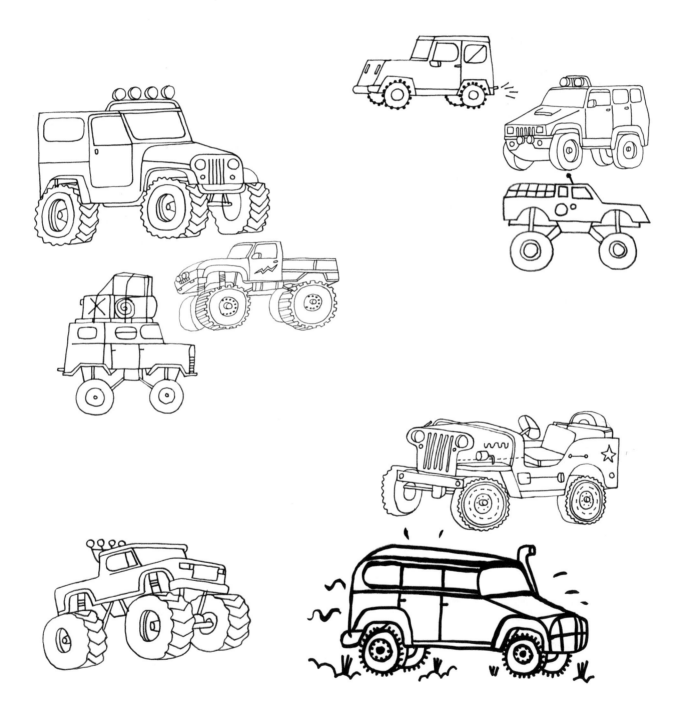

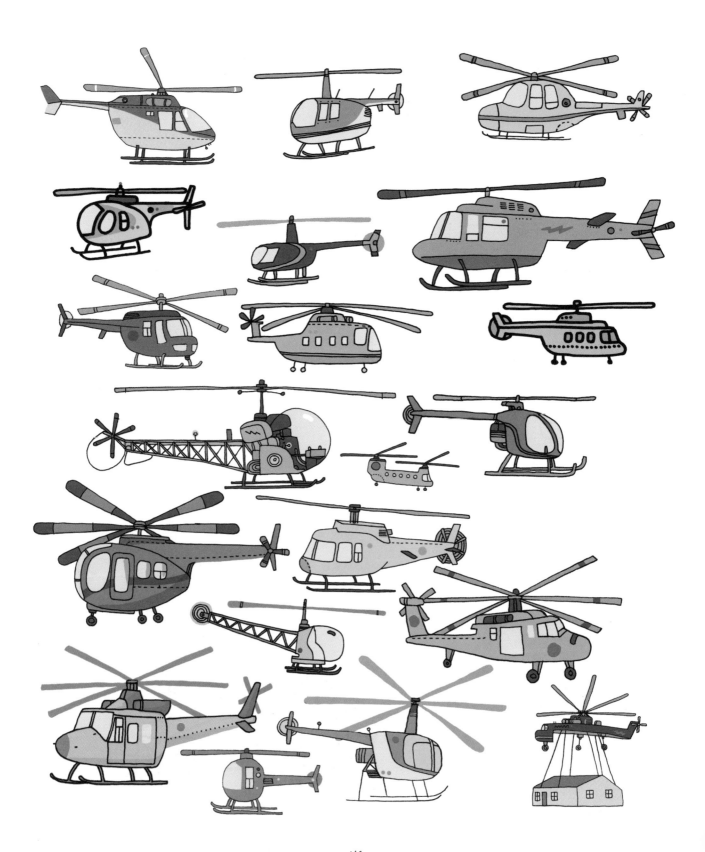

DRAW 20

Helicopters

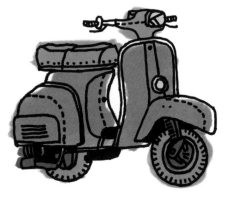
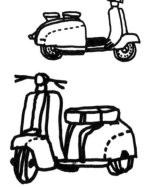
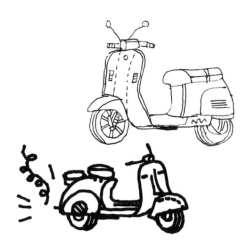
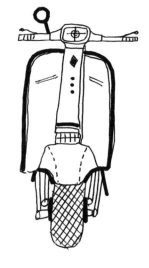
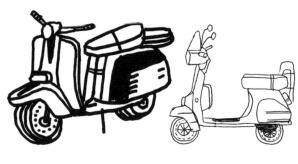
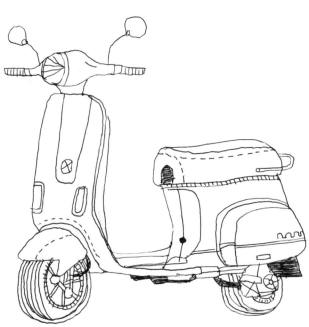

DRAW 20
Motor Scooters

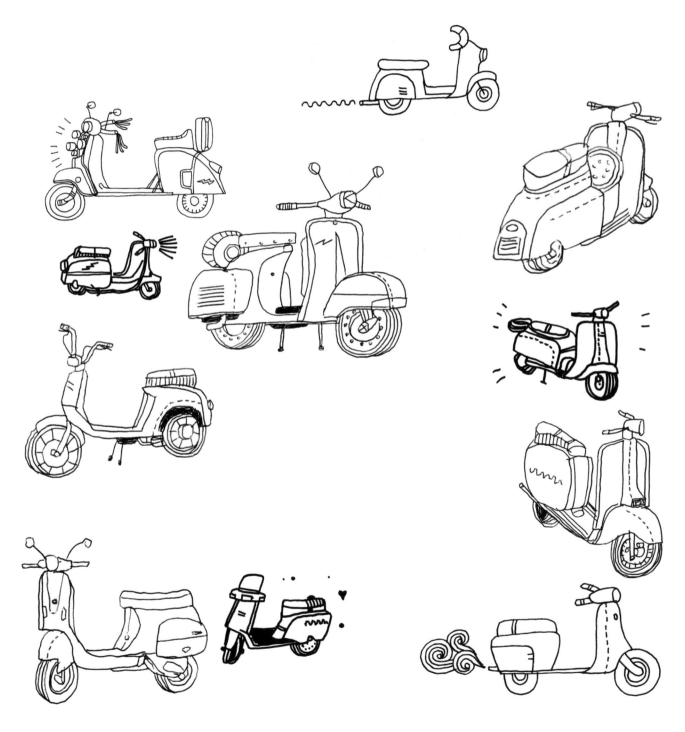

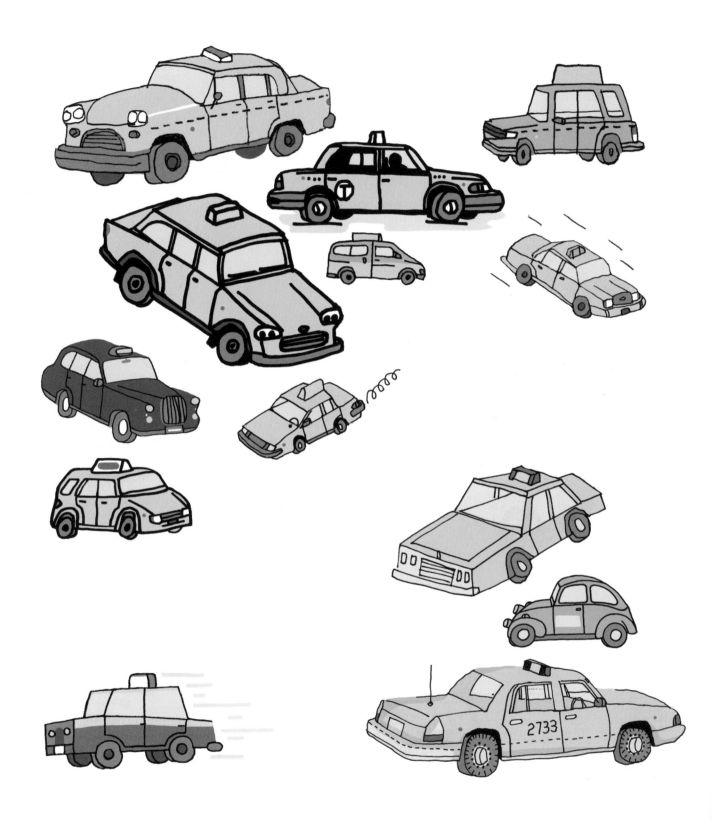

DRAW 20
taxis

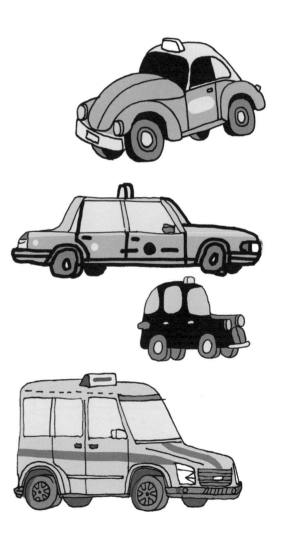

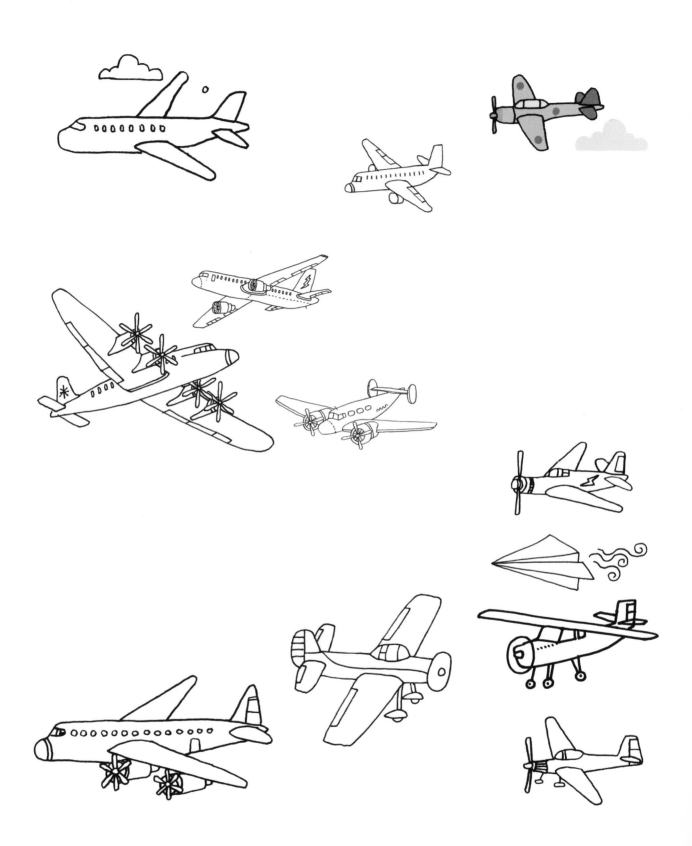

DRAW 20
jets and airplanes

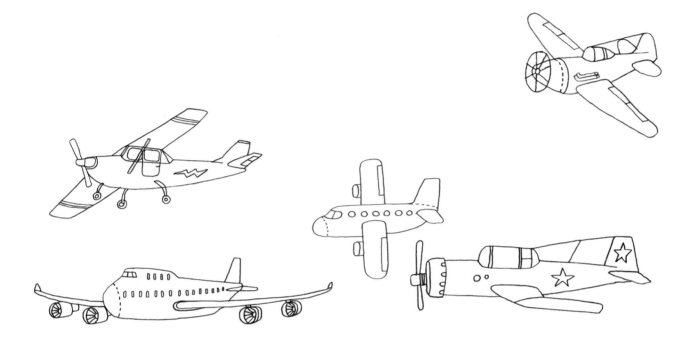

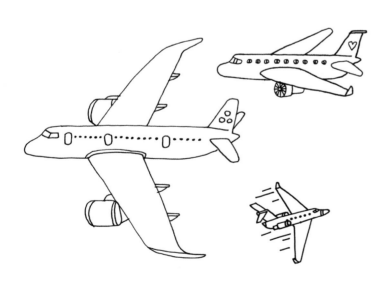

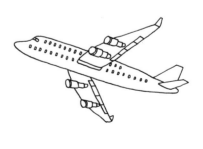

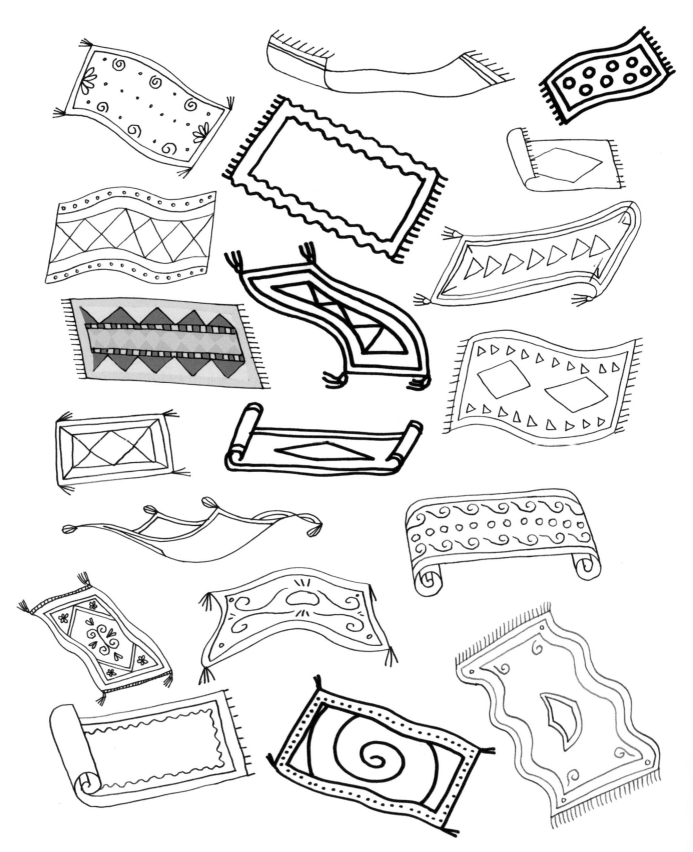

DRAW 20
MAGIC CARPETS

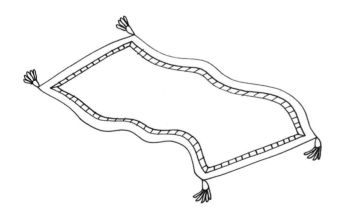

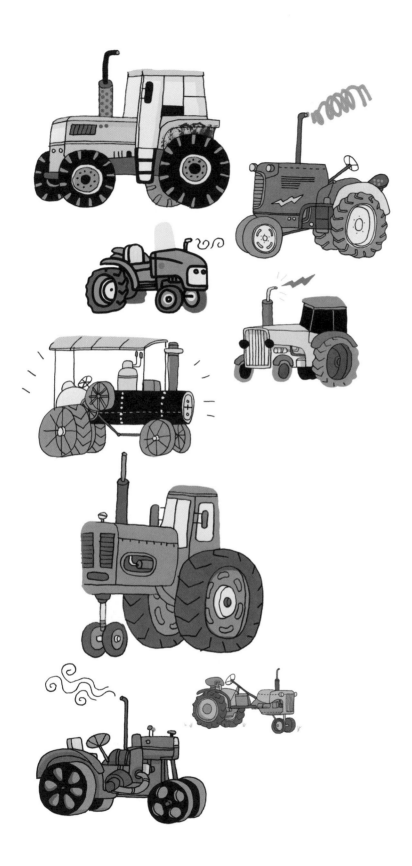

DRAW 20
Tractors

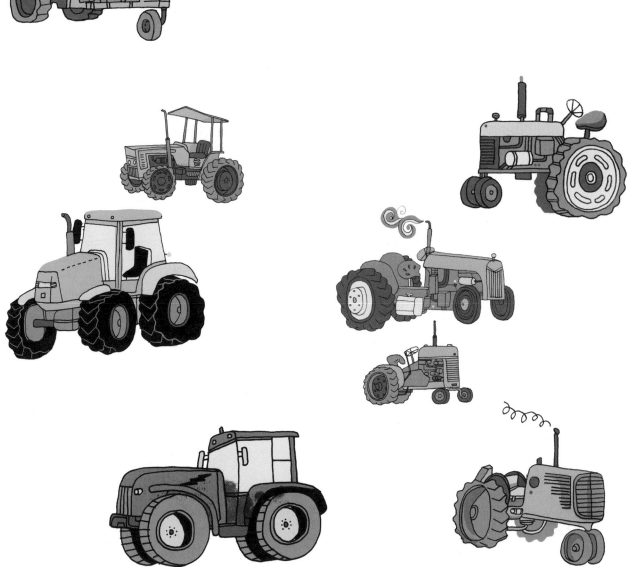

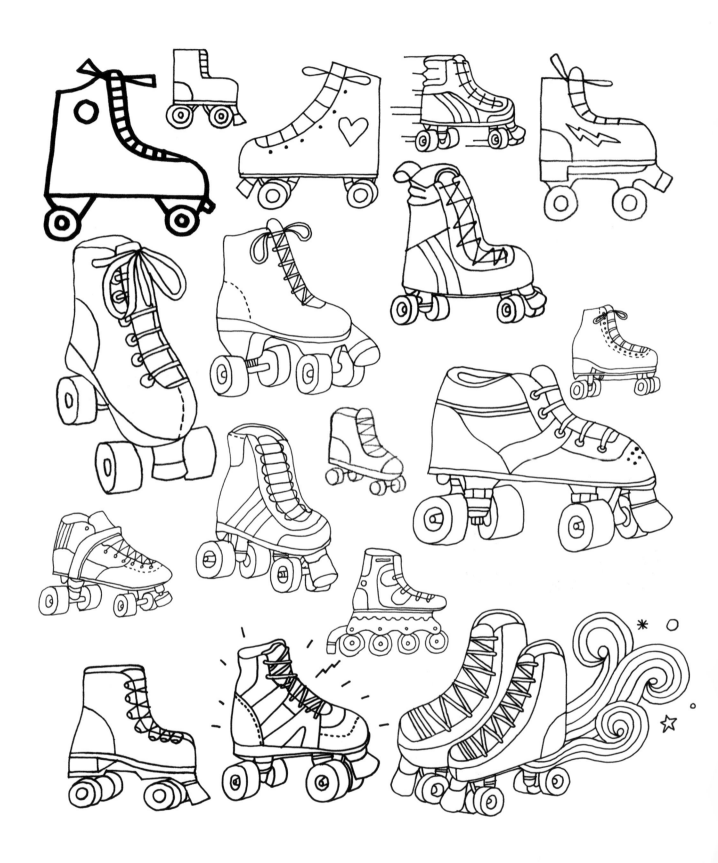

DRAW 20
ROLLER SKATES

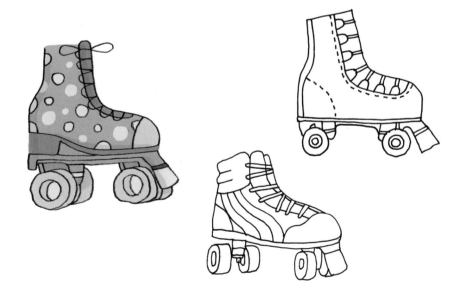

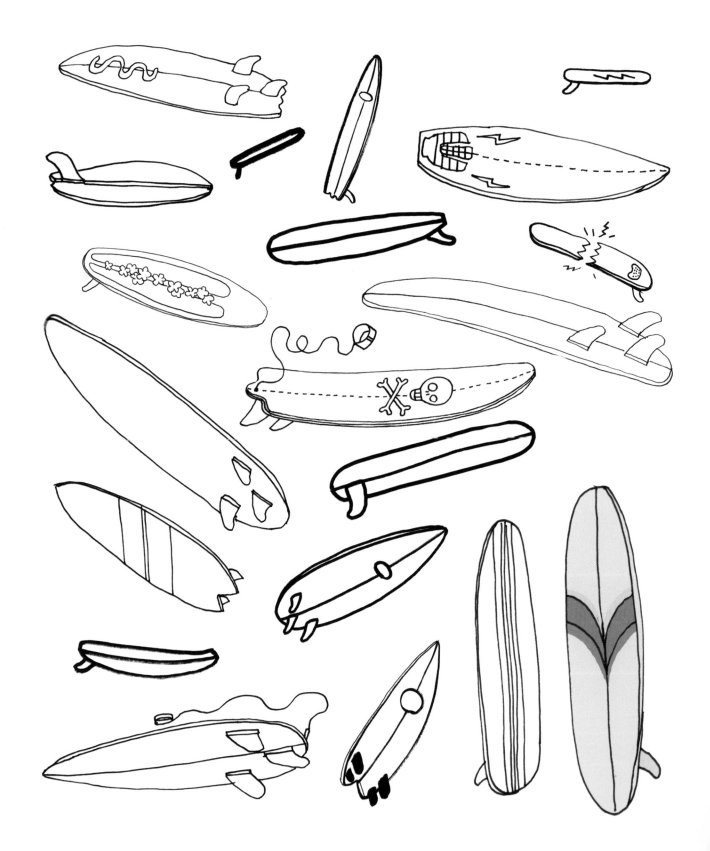

DRAW 20
Surfboards

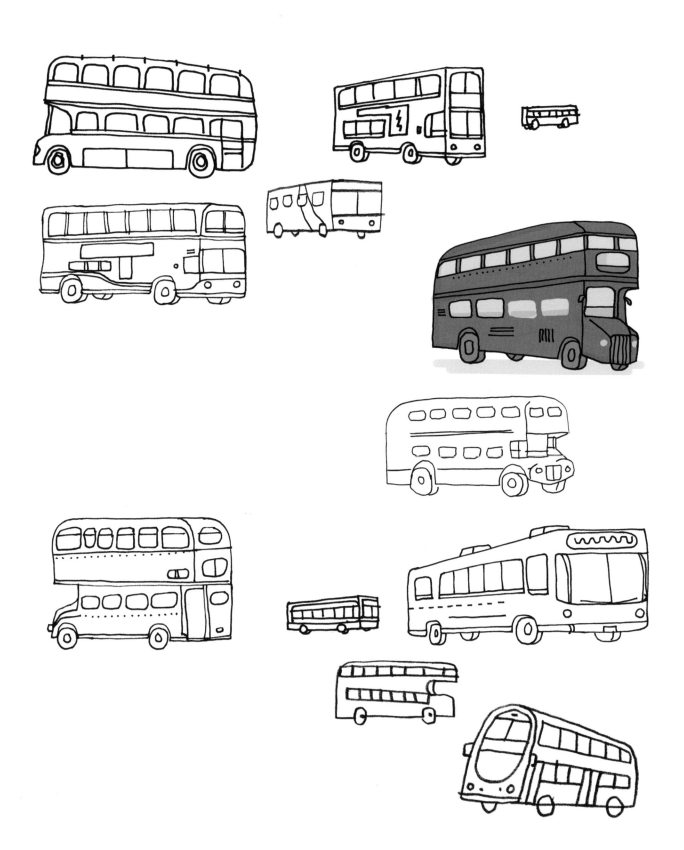

DRAW 20
BUSES

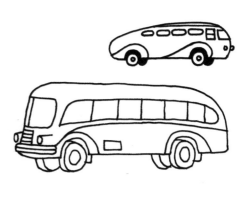

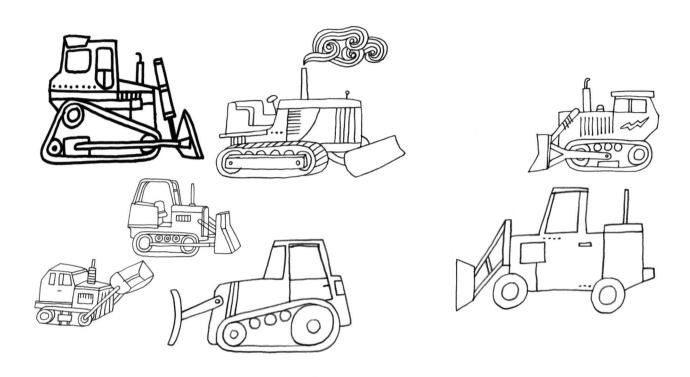

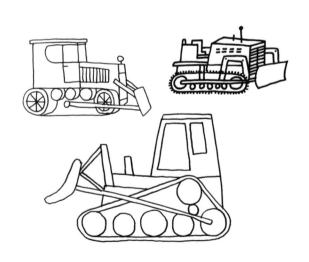

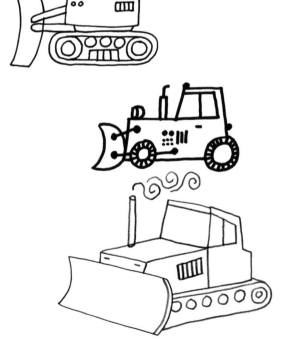

DRAW 20
bulldozers

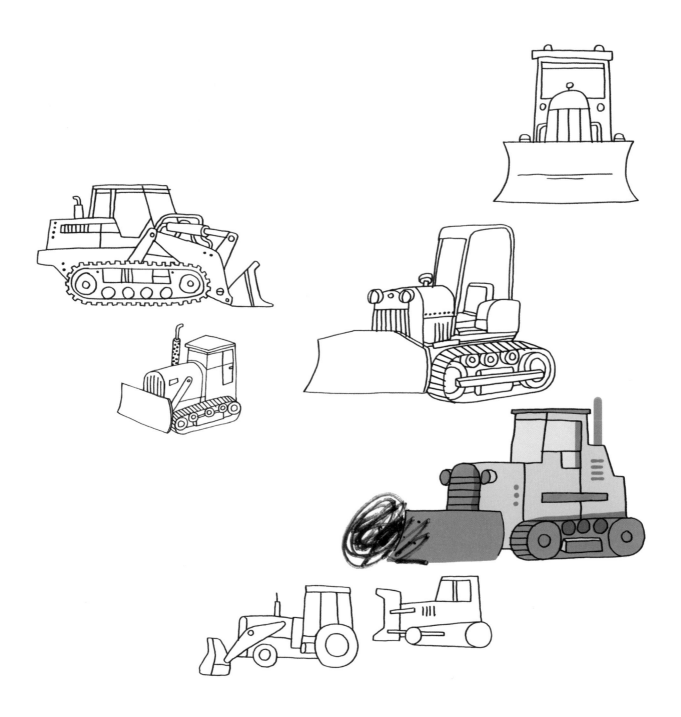

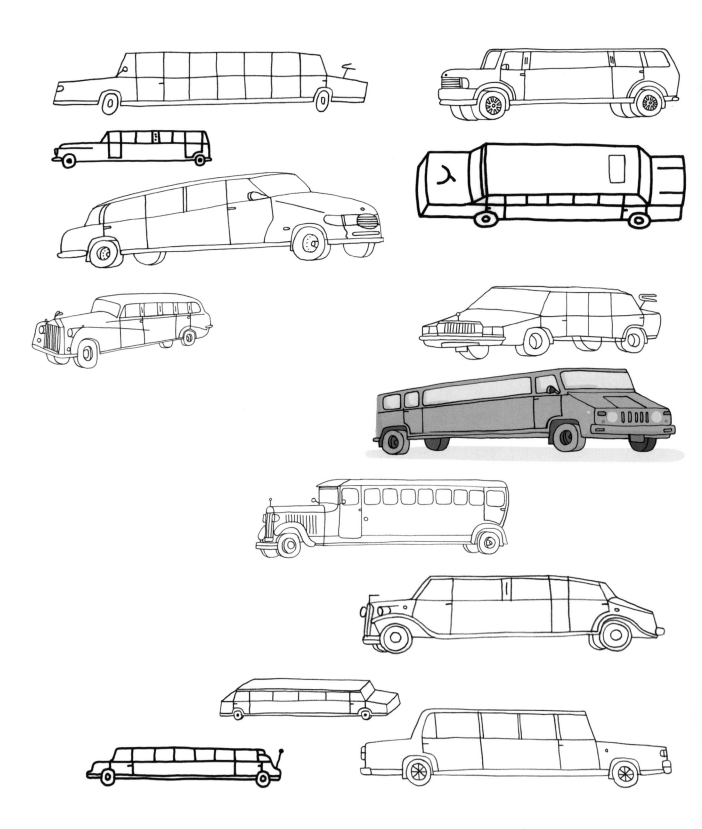

DRAW 20
Limousines

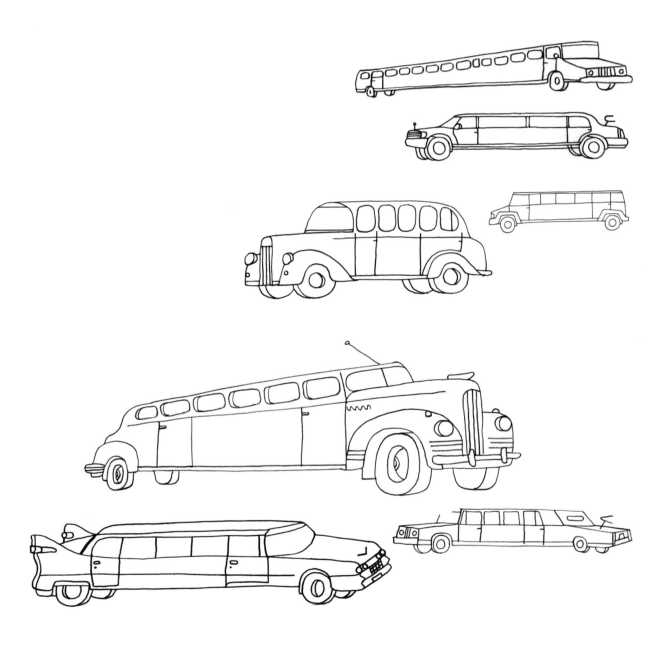

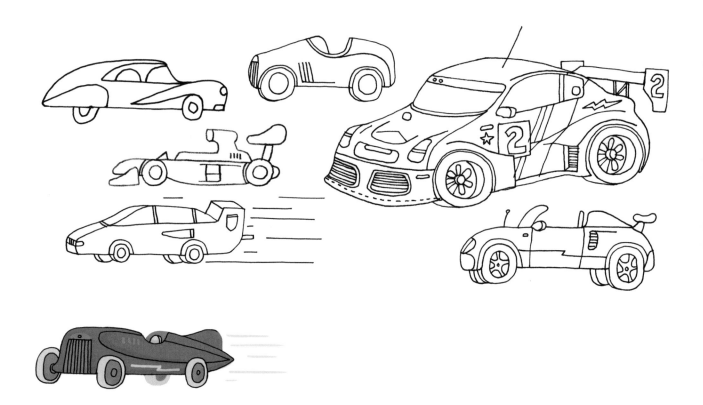
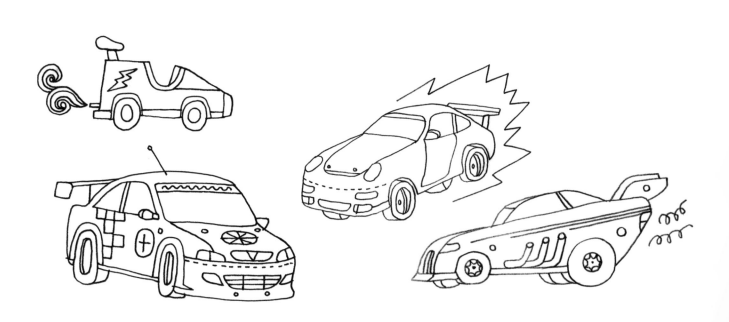

DRAW 20

RACING CARS

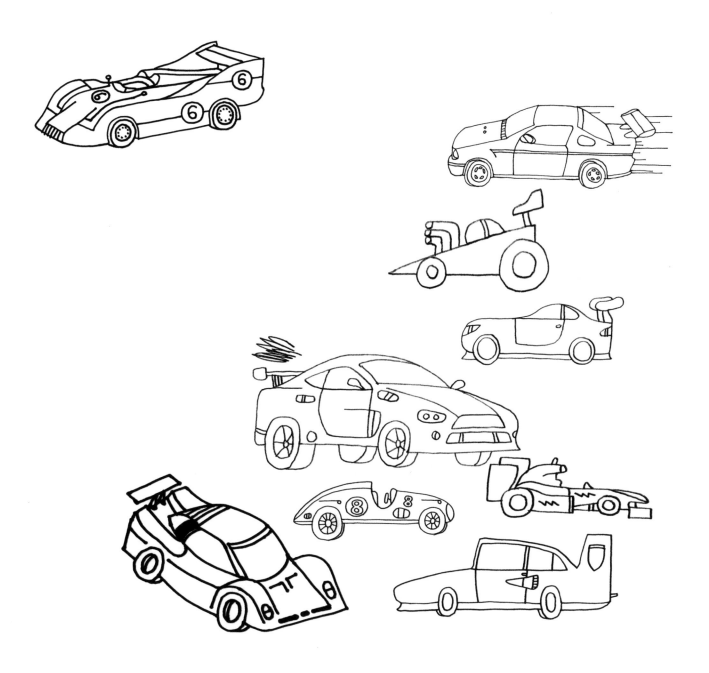

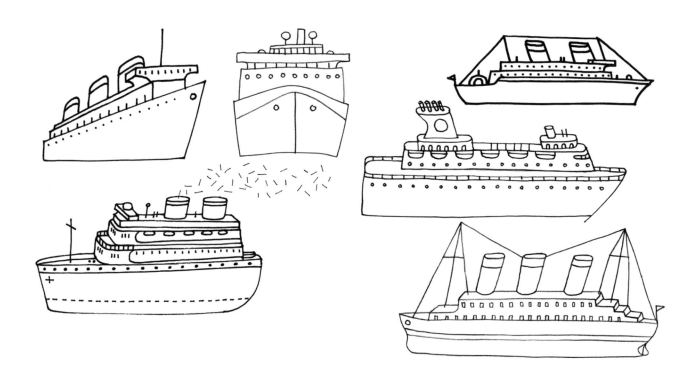

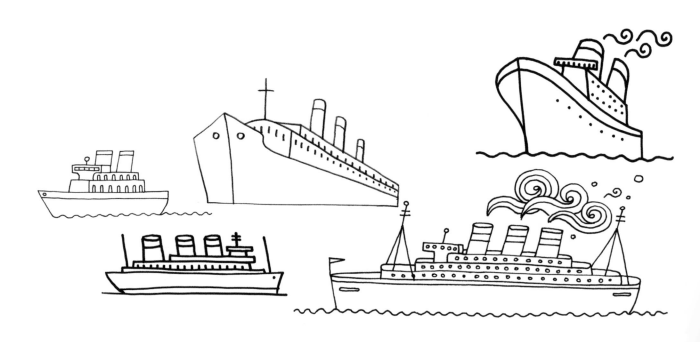

DRAW 20
OCEAN LINERS

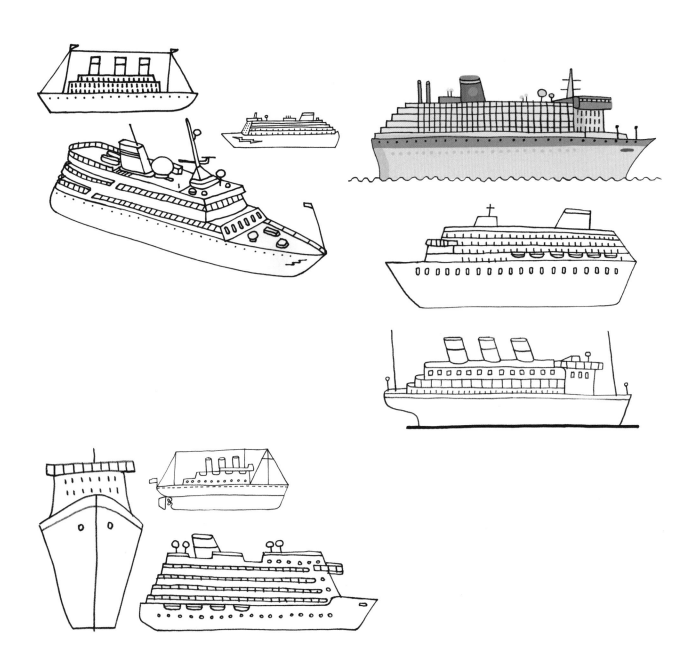

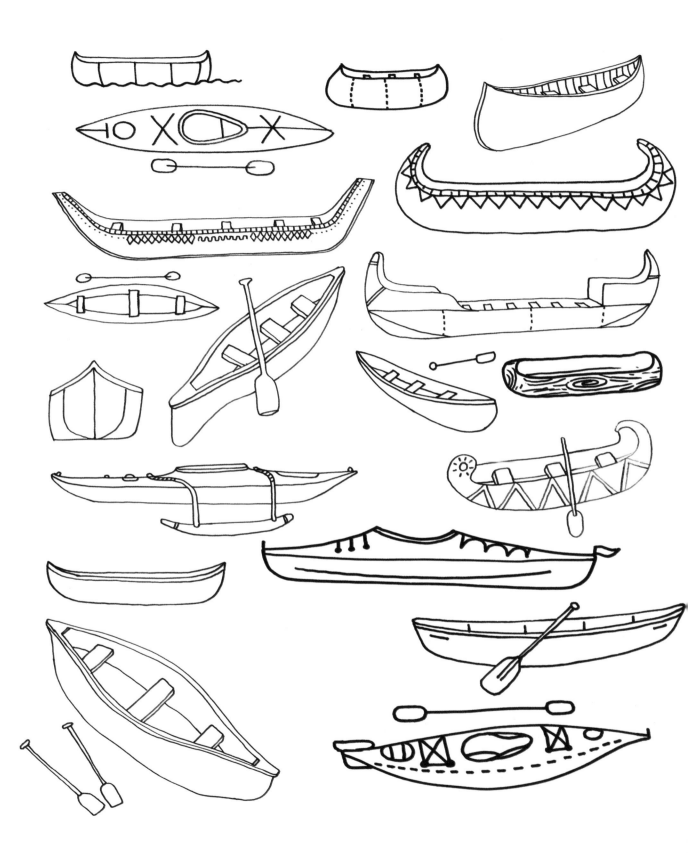

DRAW 20
Canoes

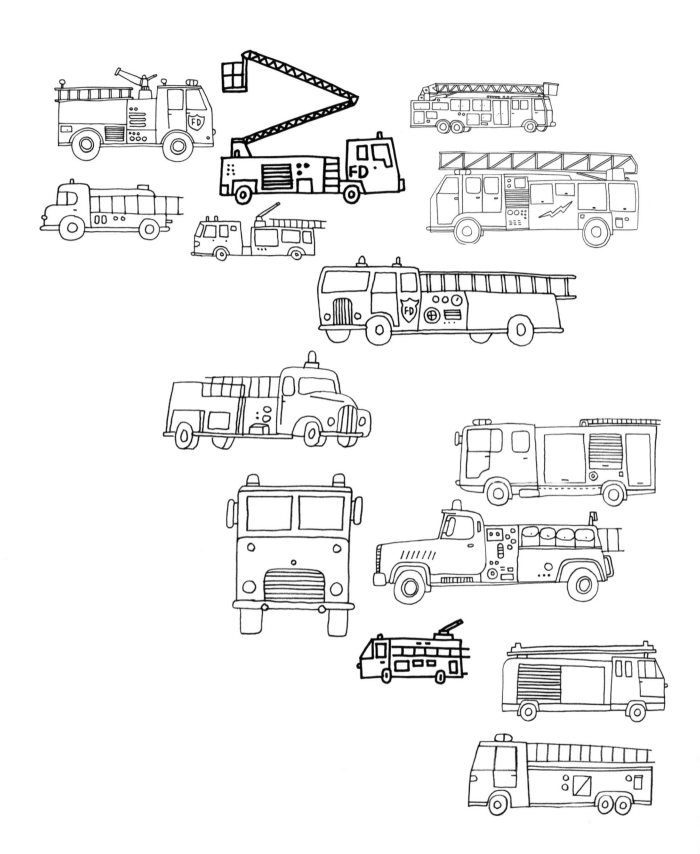

DRAW 20
FIRE ENGINES

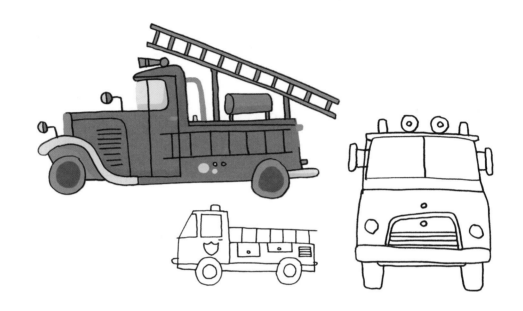

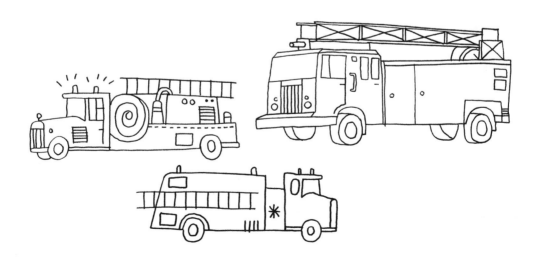

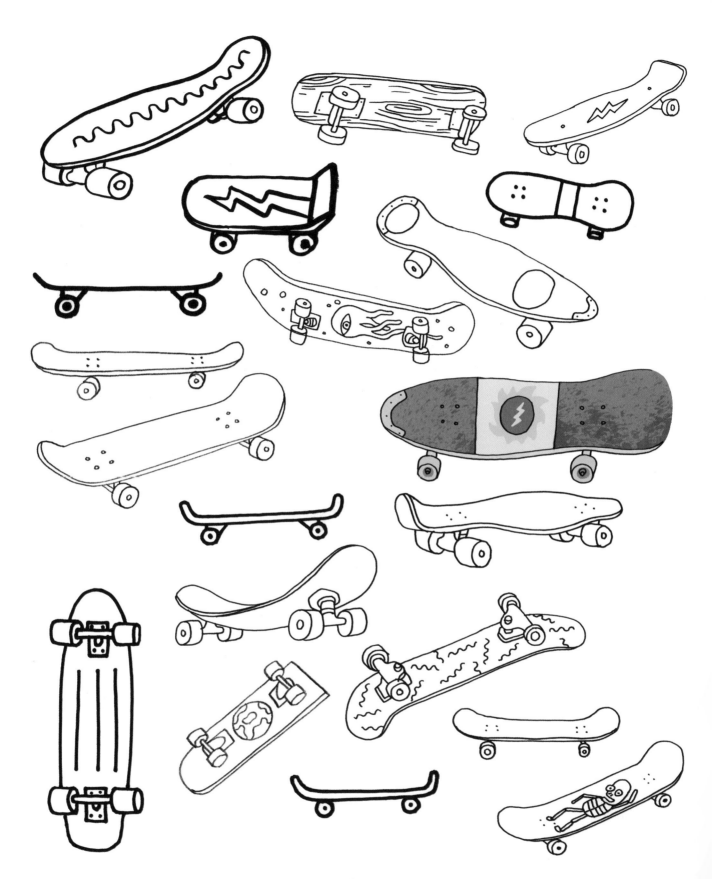

DRAW 20
SKATEBOARDS

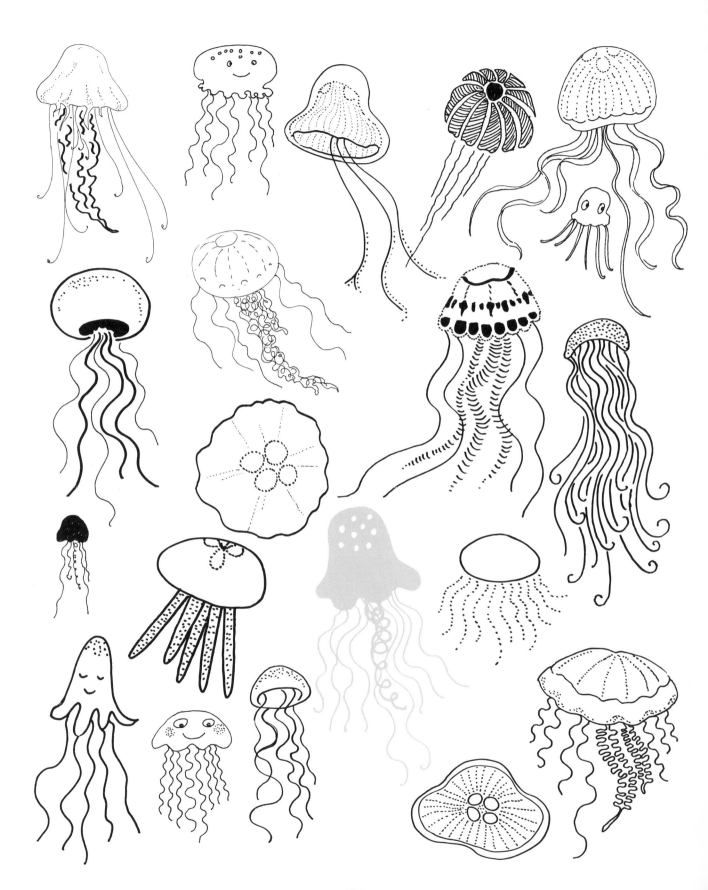

DRAW 20
Jellyfish

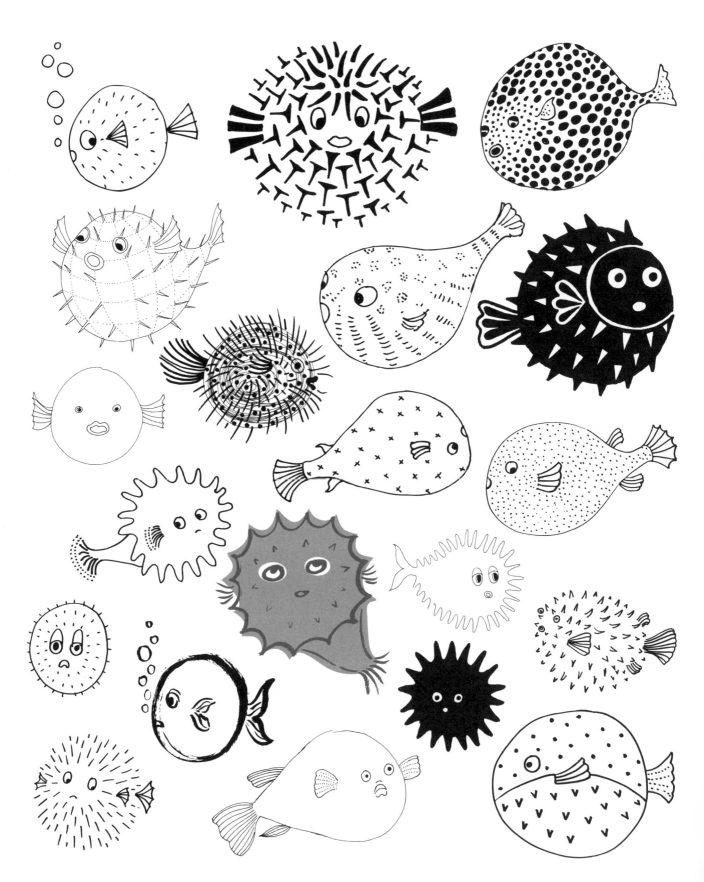

DRAW 20
PUFFER FISH

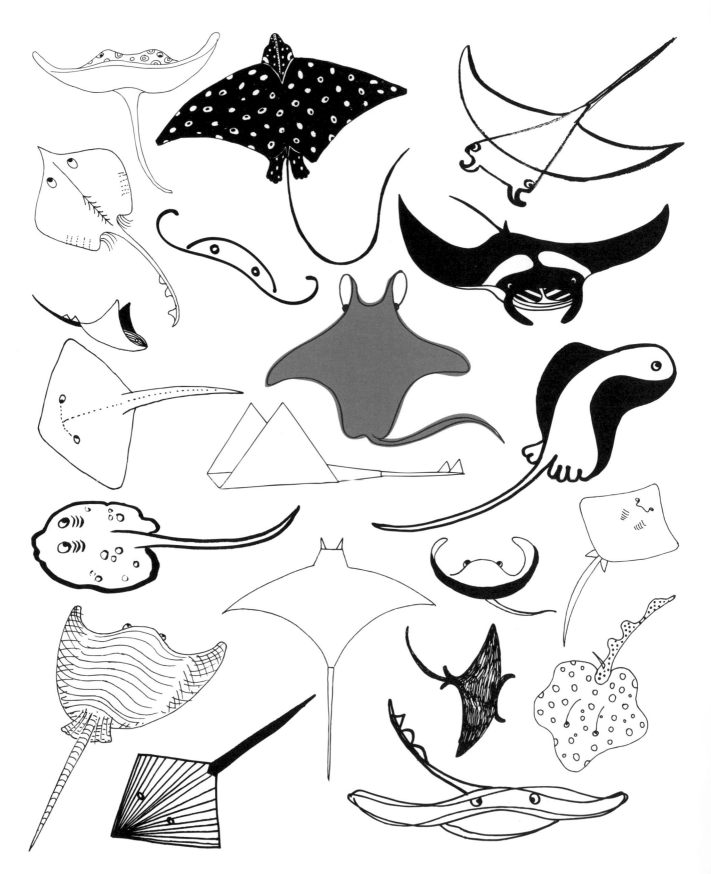

DRAW 20
Rays

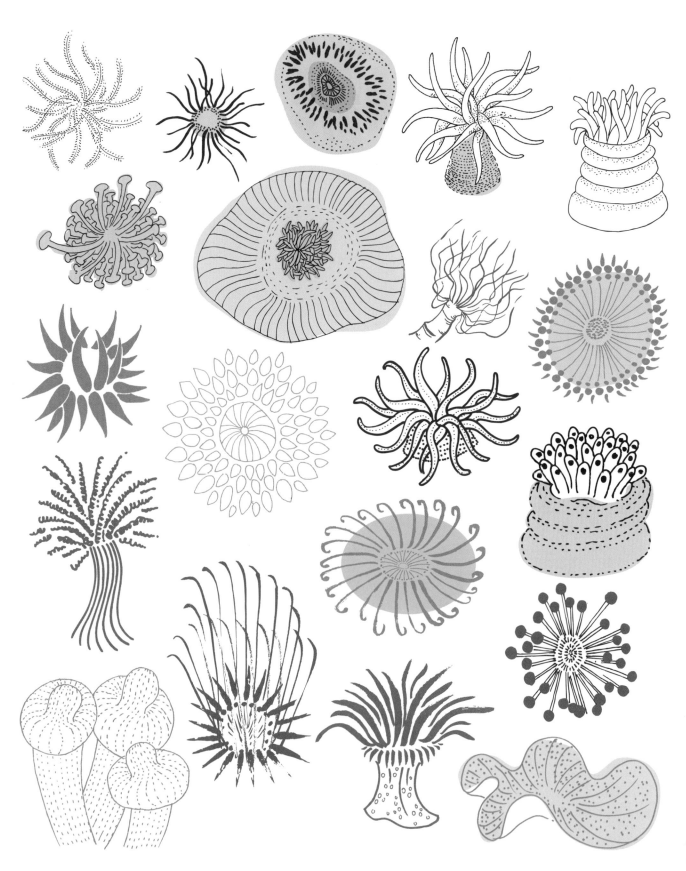

DRAW 20
Anemones

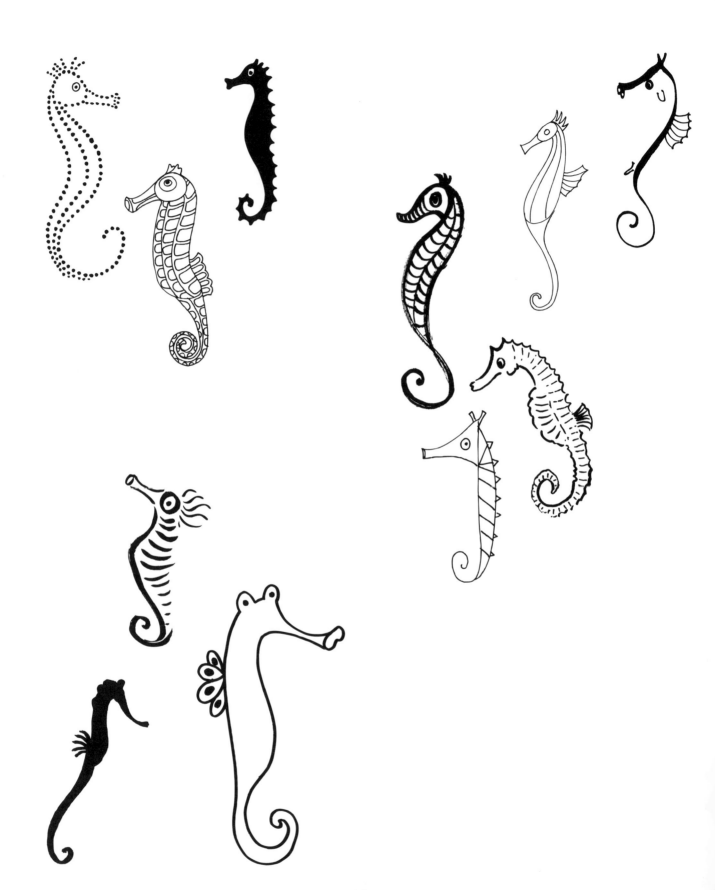

DRAW 20
SeAHORSeS

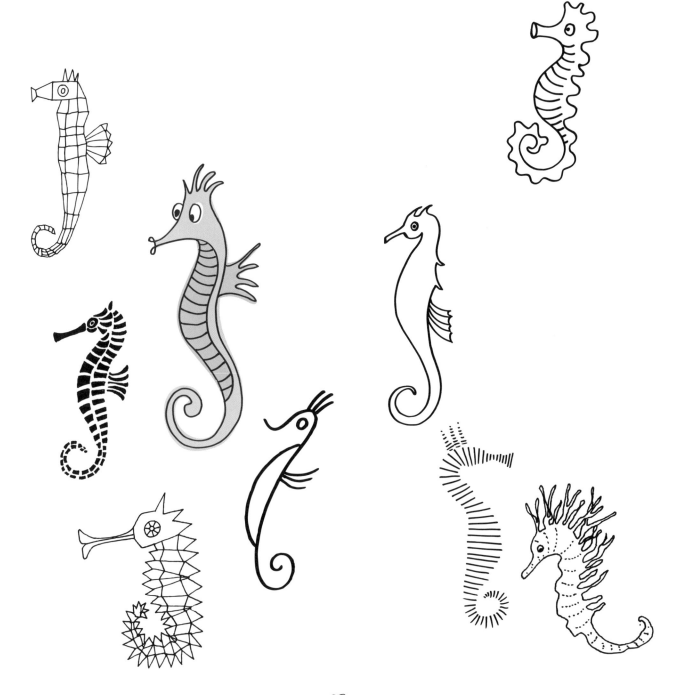

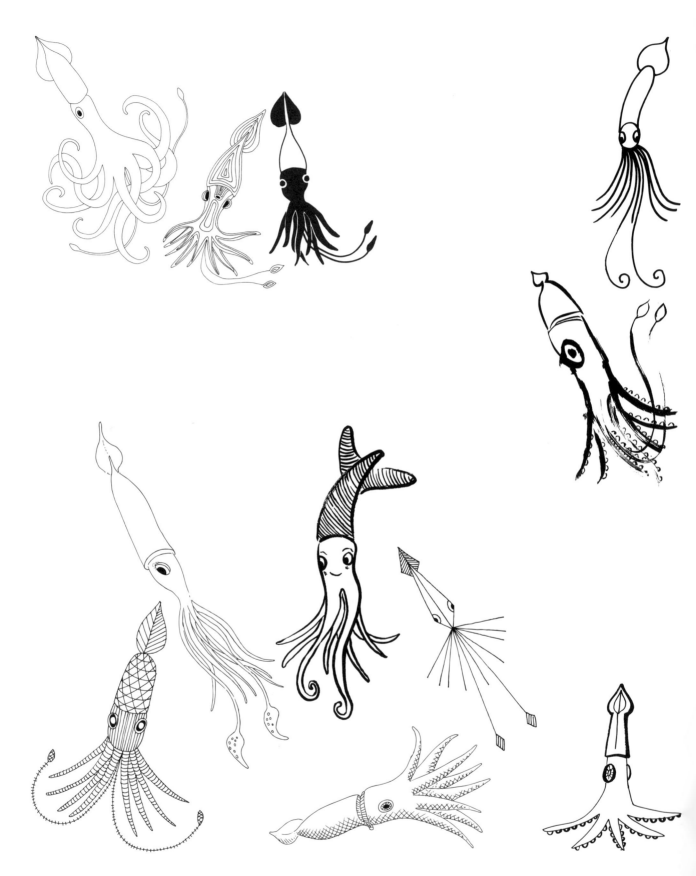

DRAW 20
SQUID

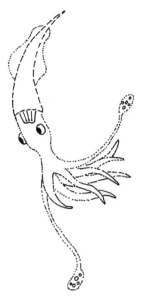

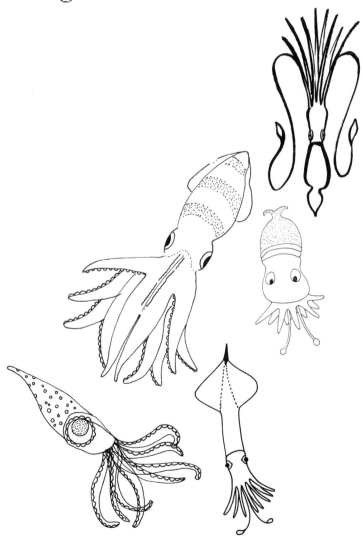

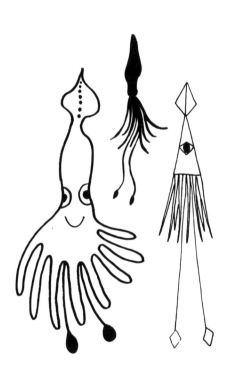

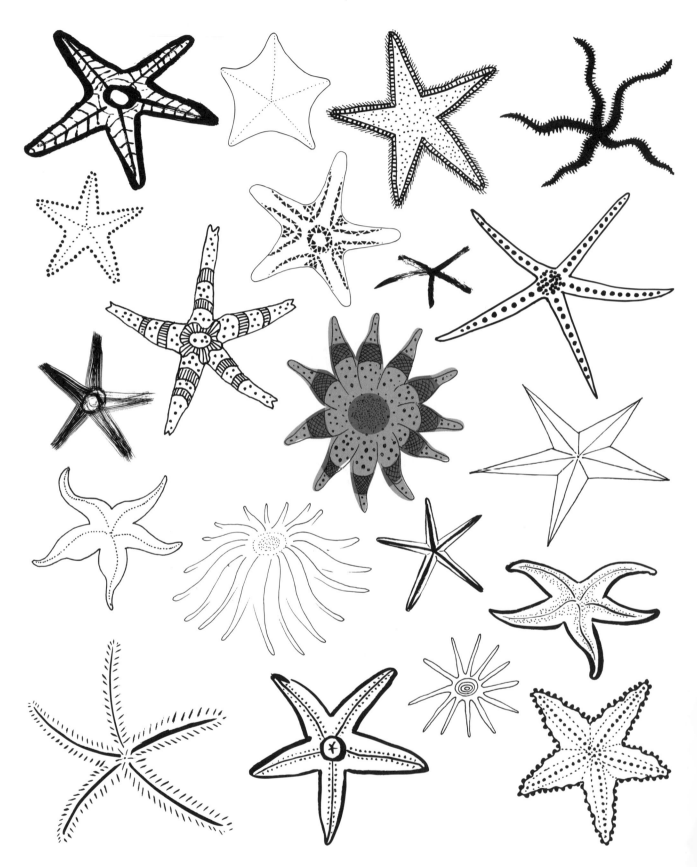

DRAW 20
Starfish

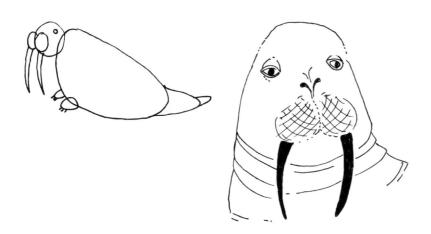

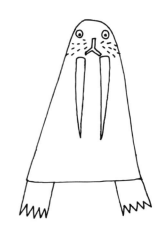

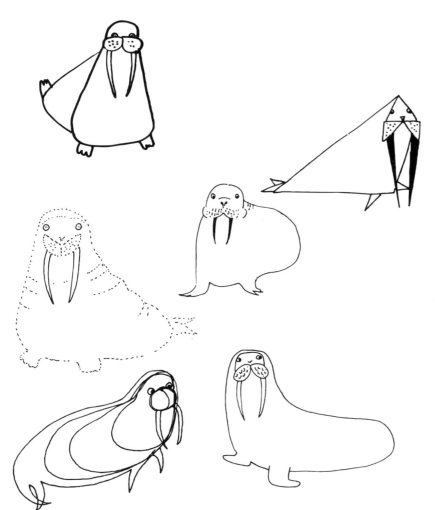

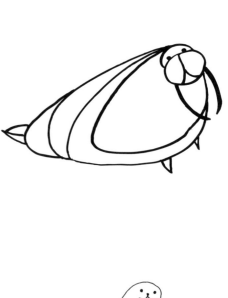

DRAW 20
WALRUSES

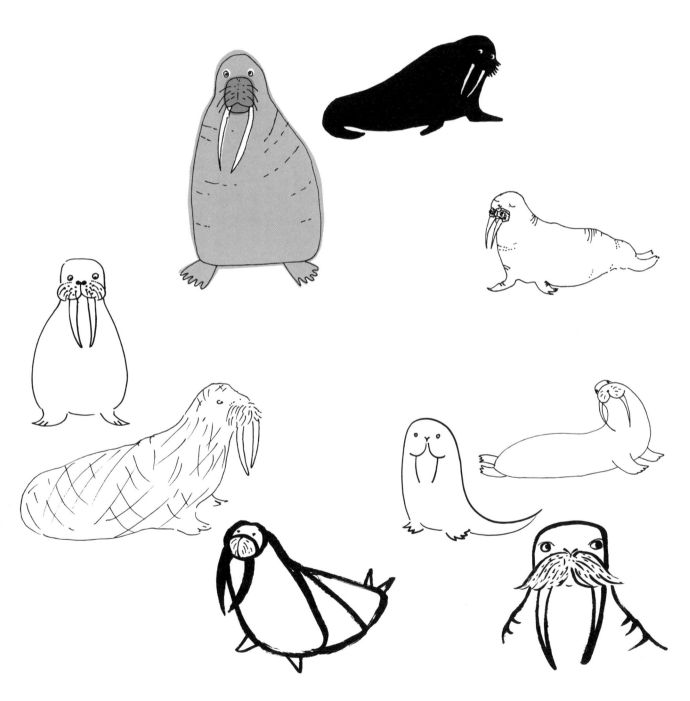

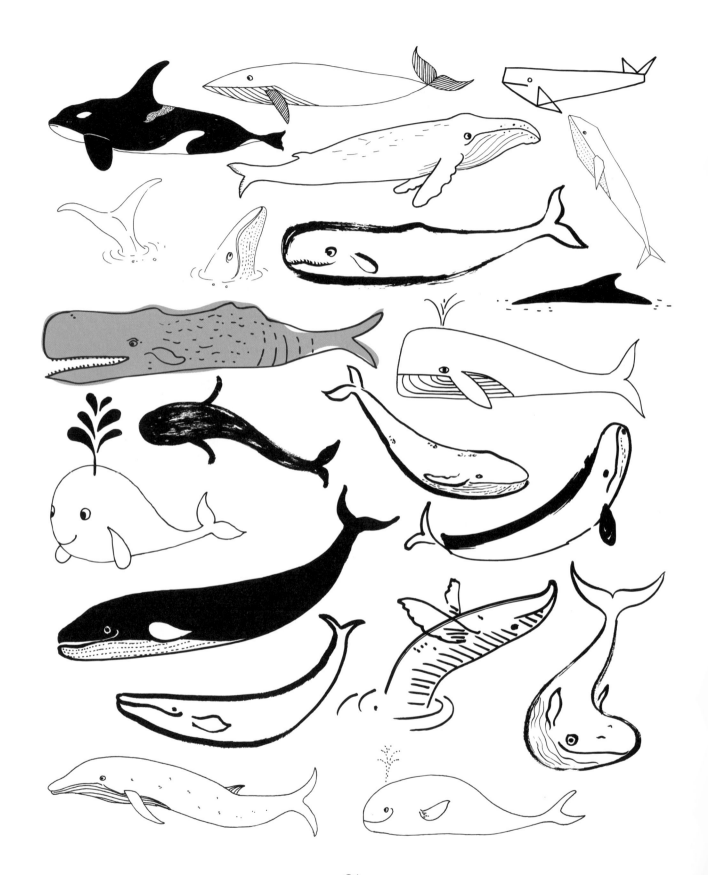

DRAW 20
Whales

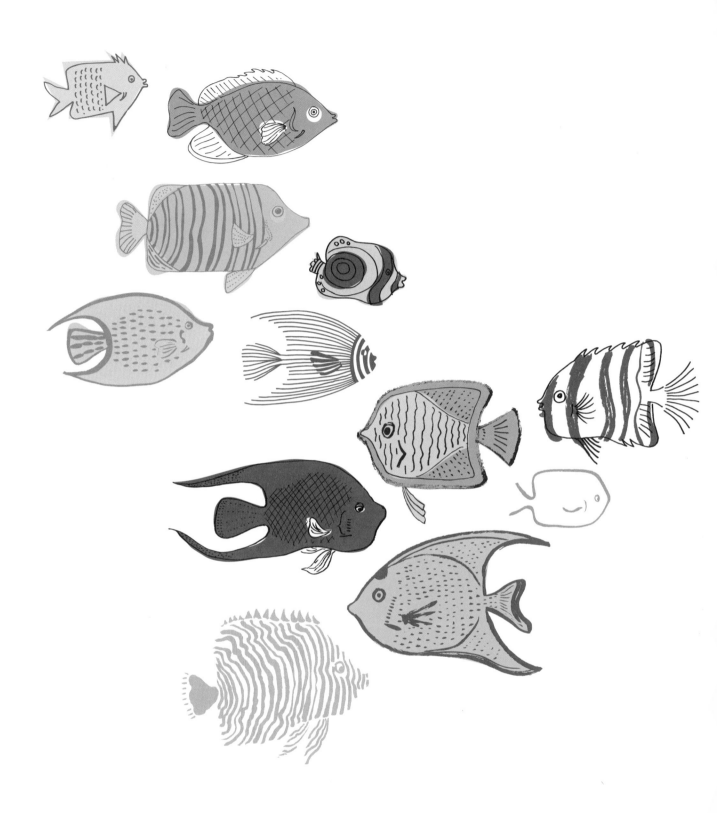

Angelfish

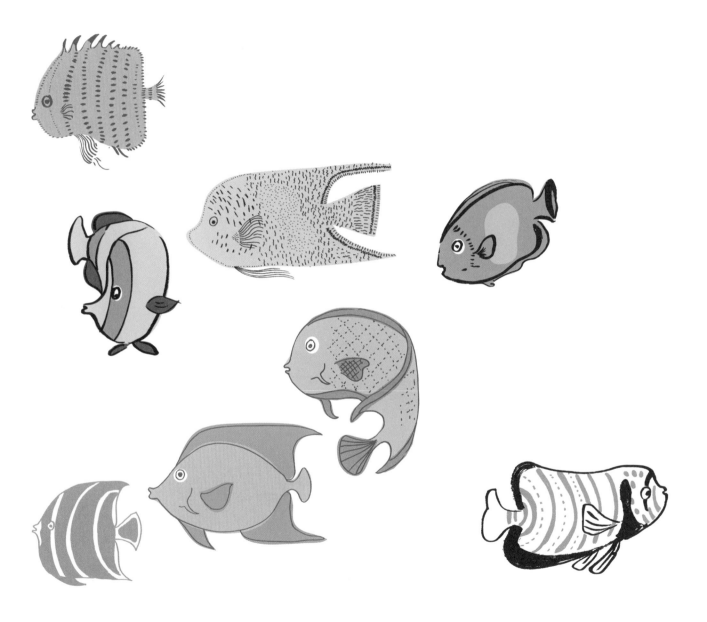

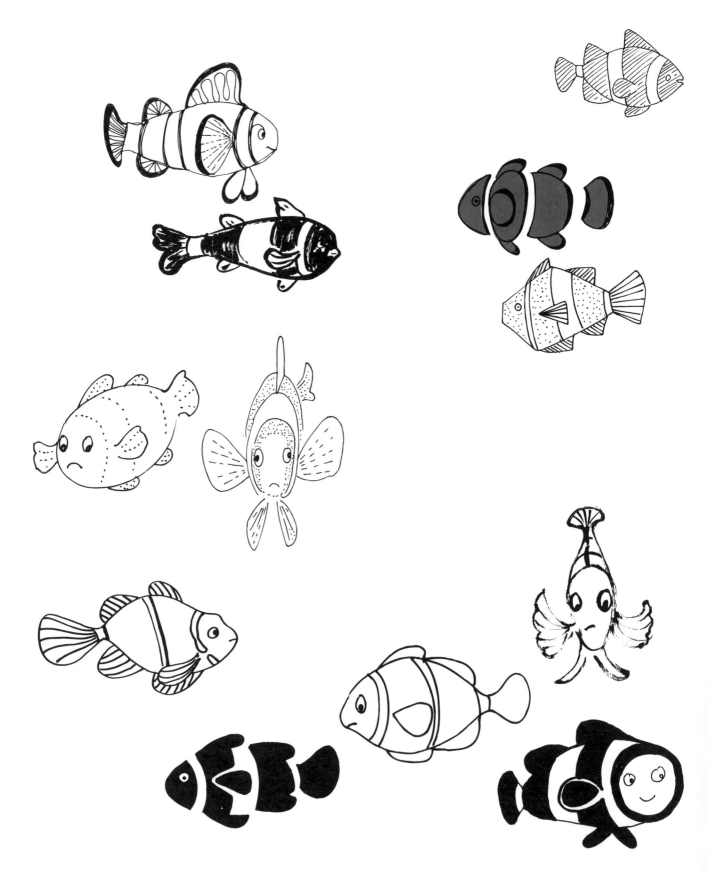

DRAW 20
CLOWN FISH

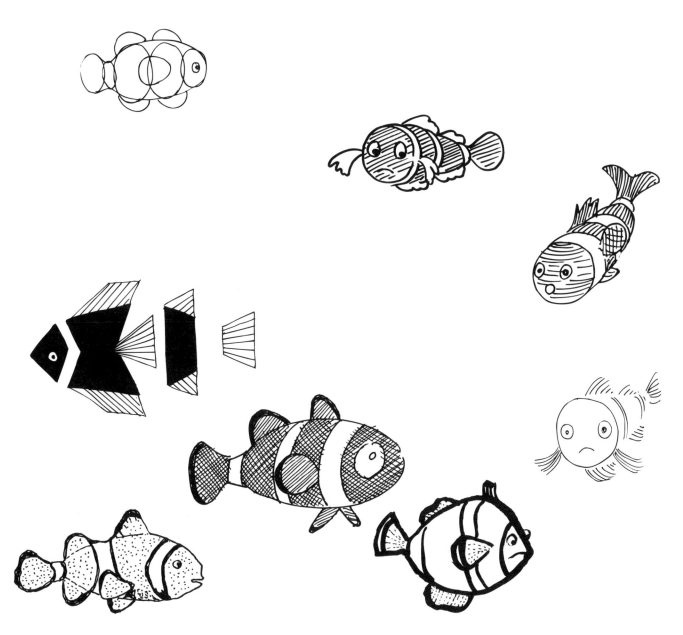

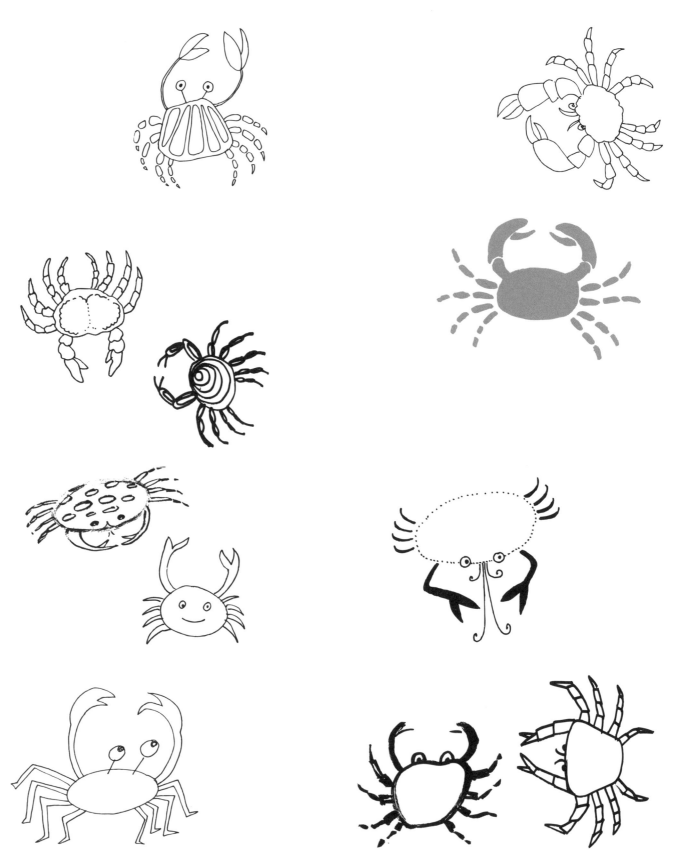

DRAW 20
CRABS

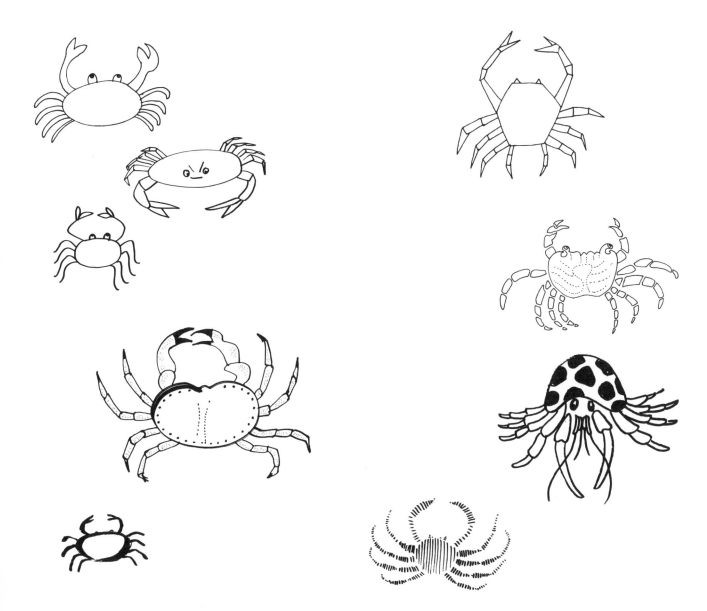

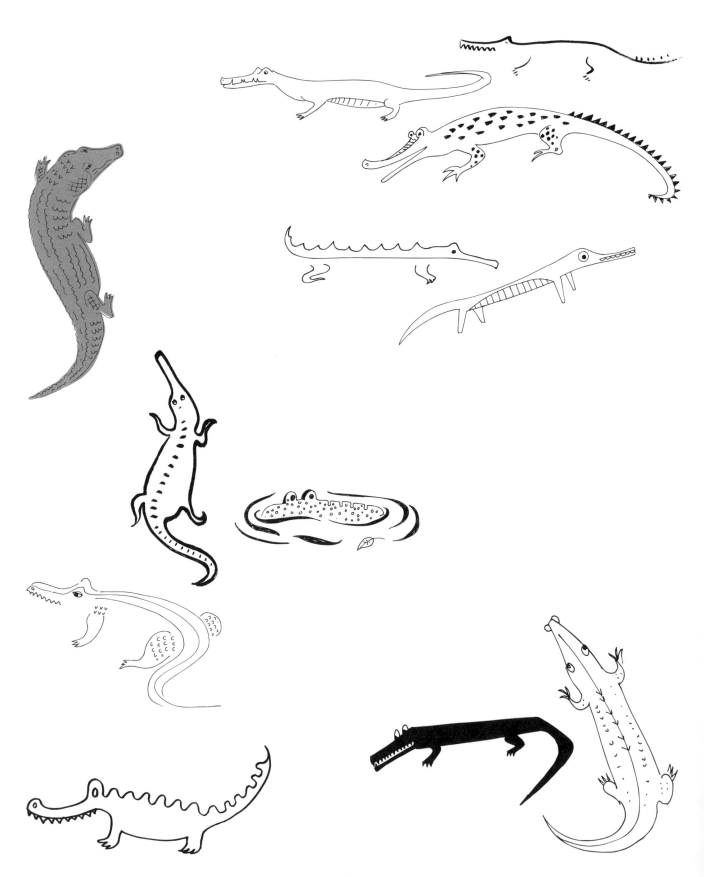

DRAW 20
CROCODILES

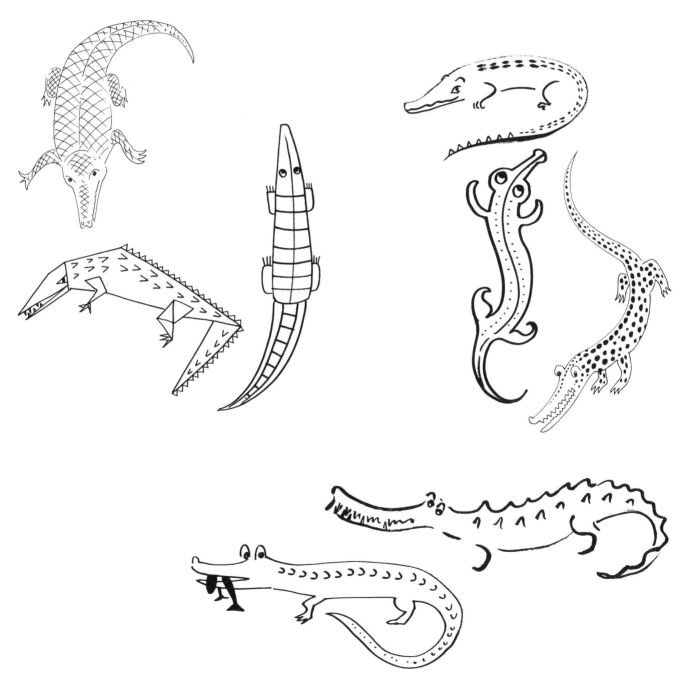

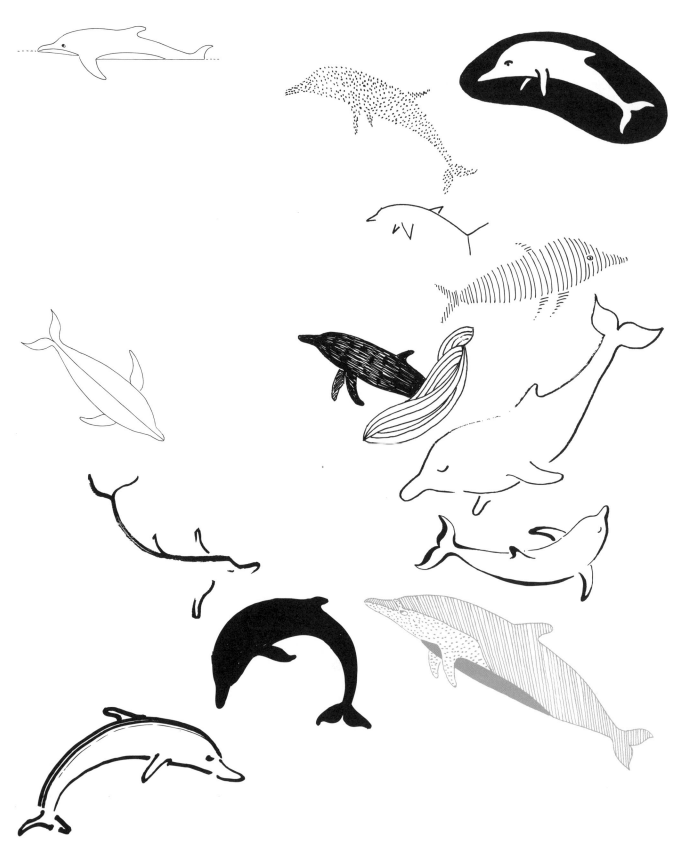

DRAW 20
Dolphins

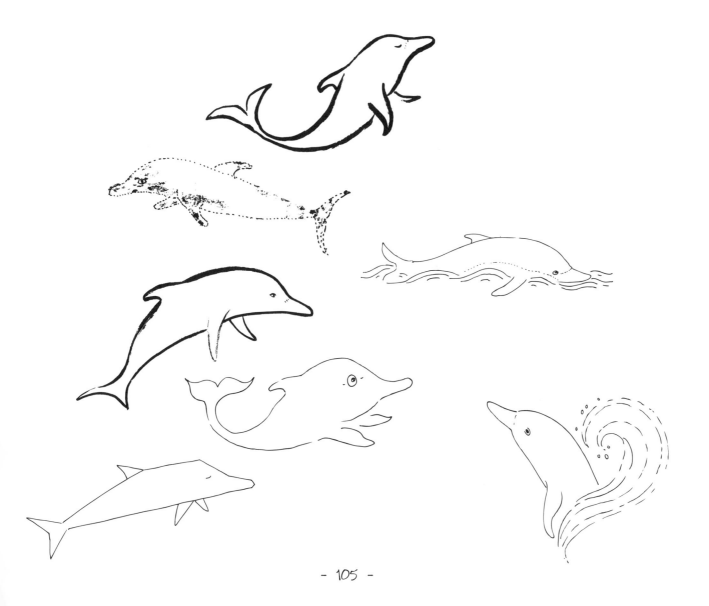

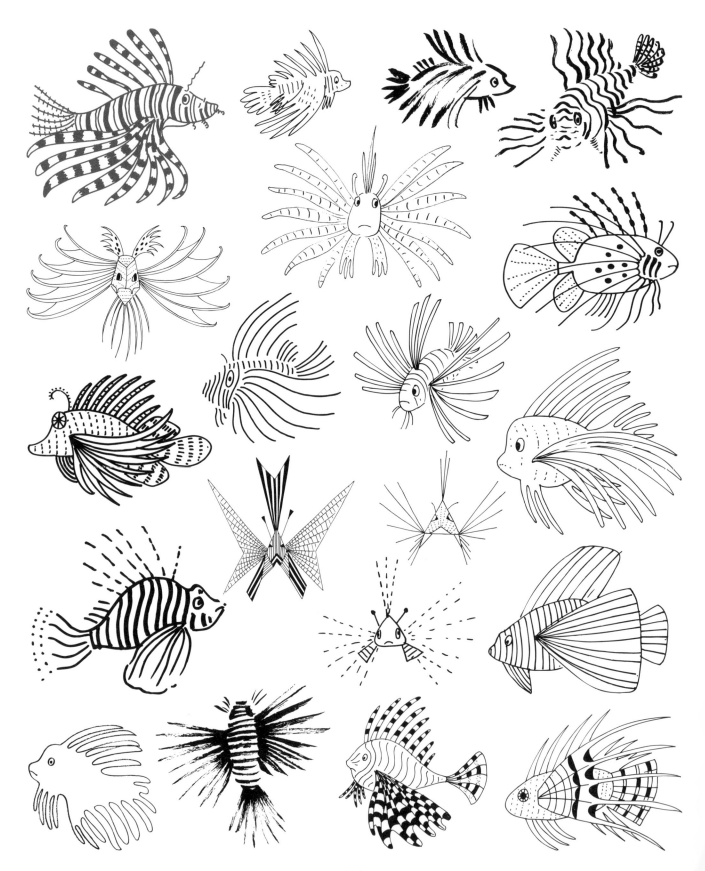

DRAW 20
Lionfish

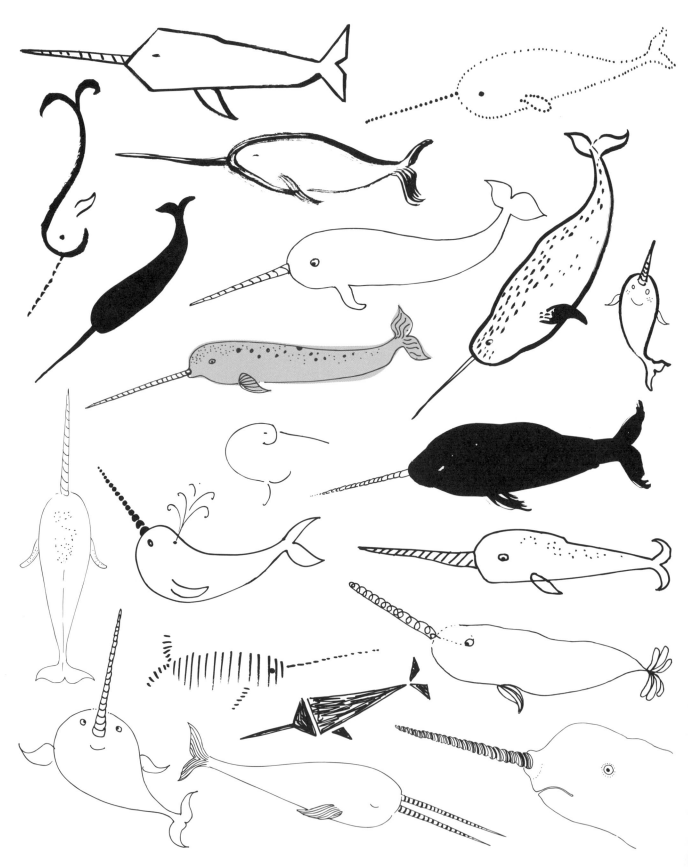

DRAW 20
NARWHALS

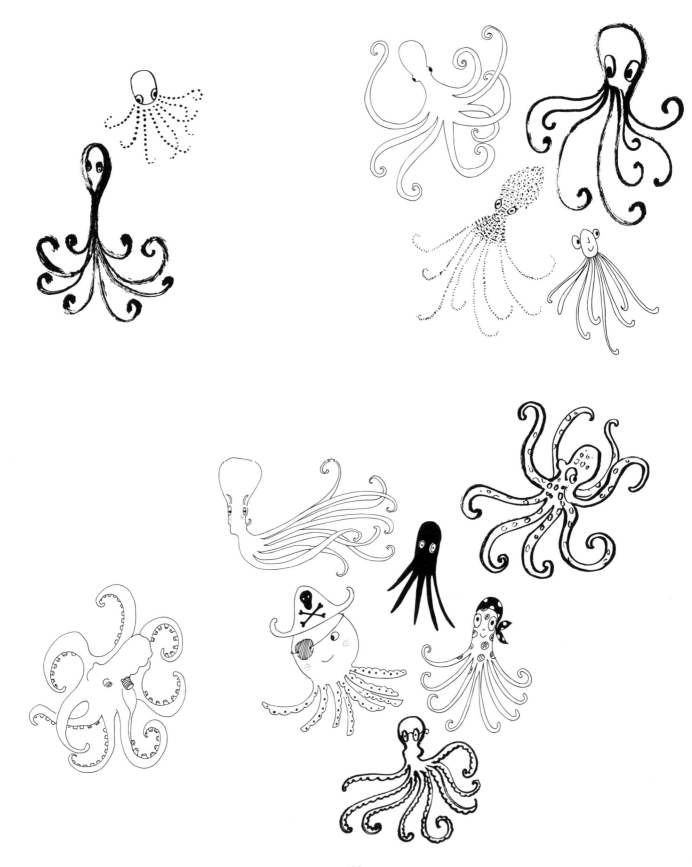

DRAW 20
Octopi

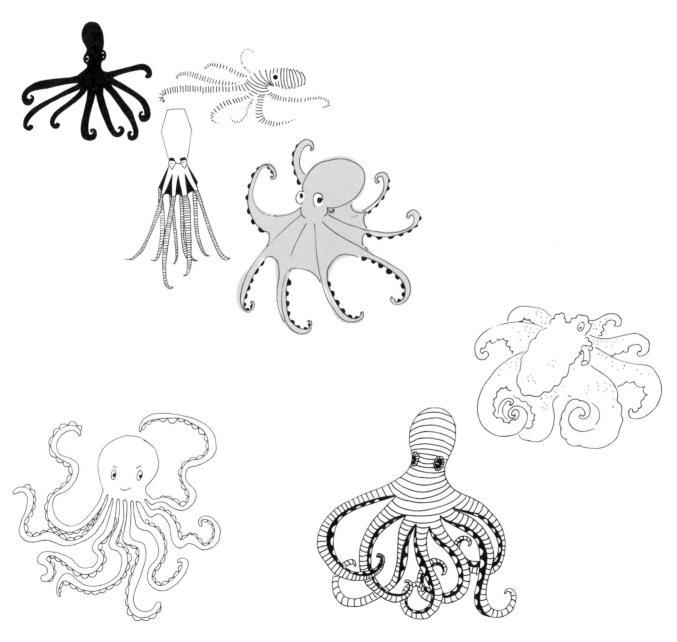

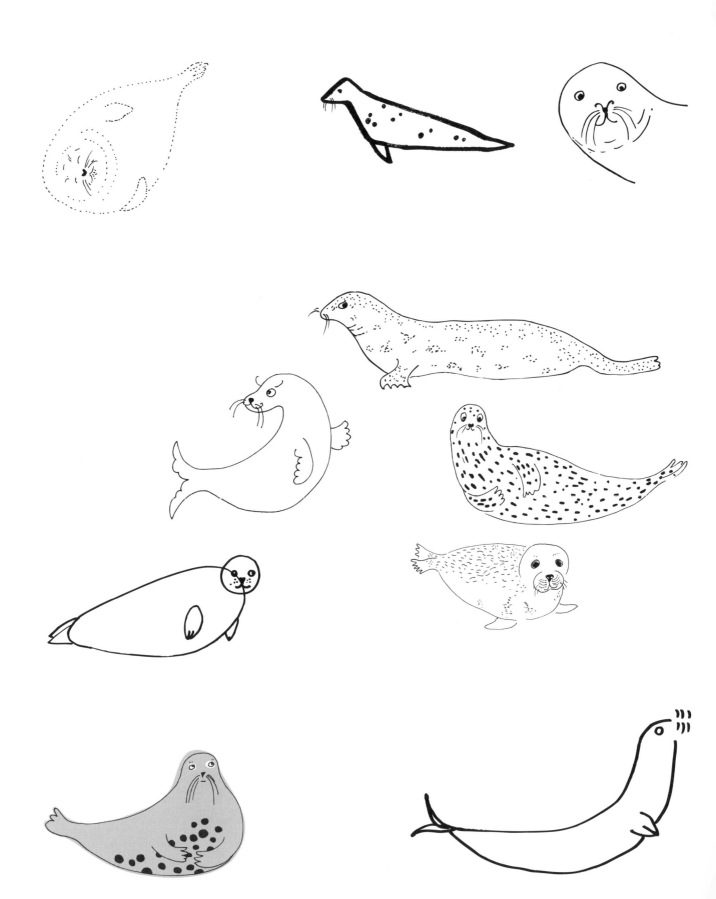

DRAW 20
Seals

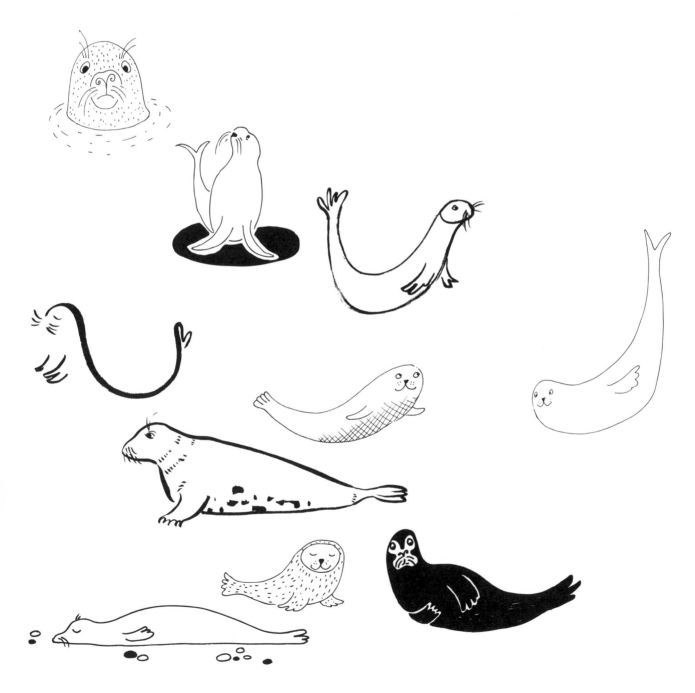

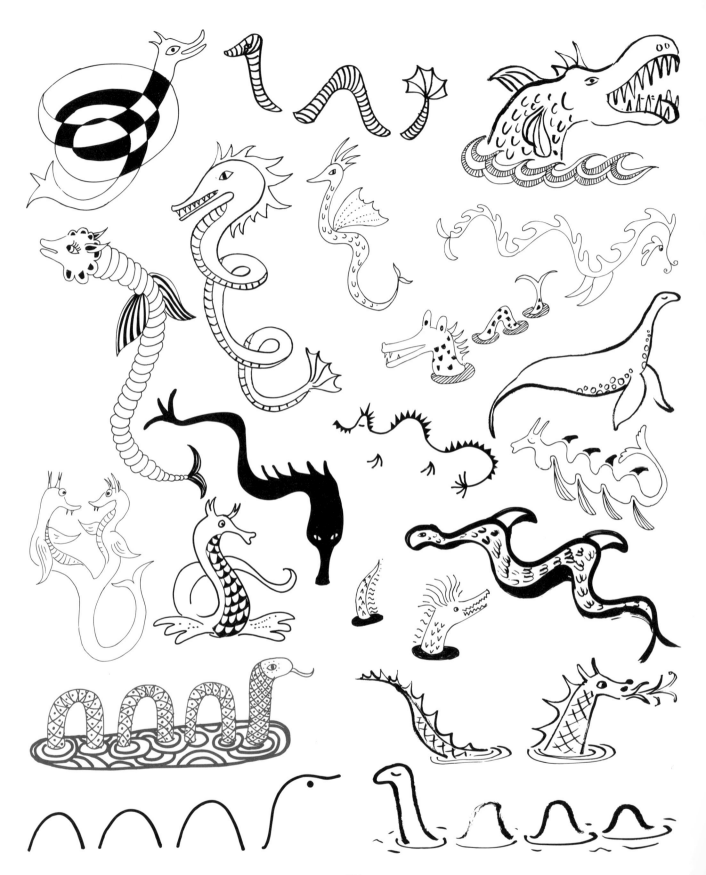

DRAW 20
Sea Serpents

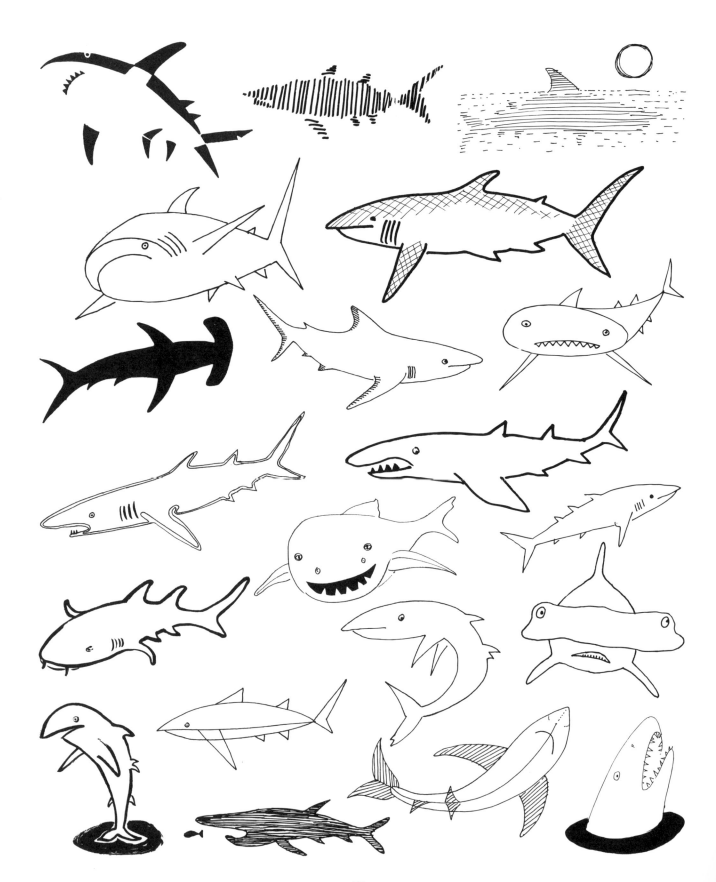

DRAW 20
Sharks

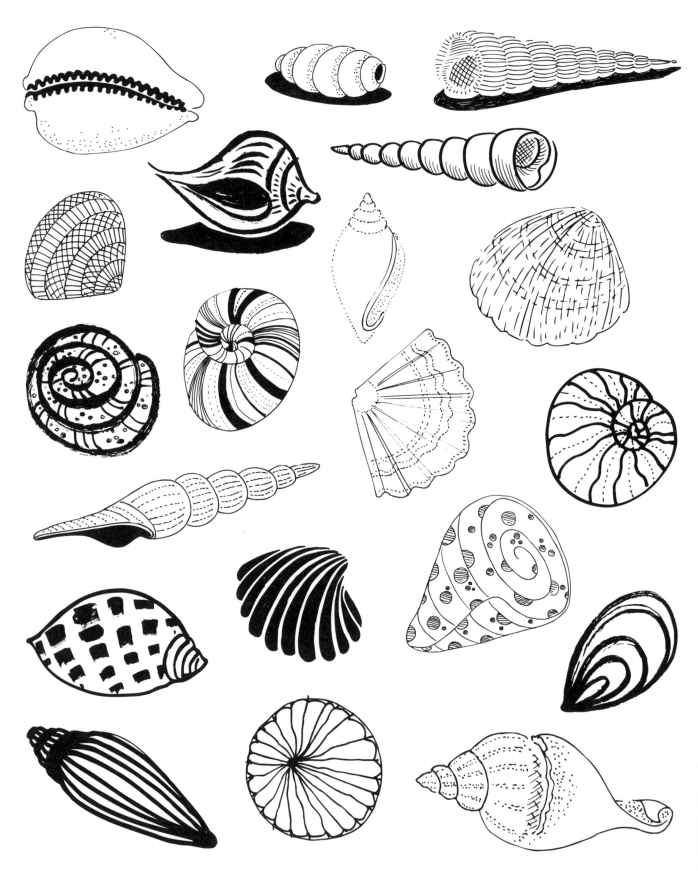

DRAW 20
SEASHELLS

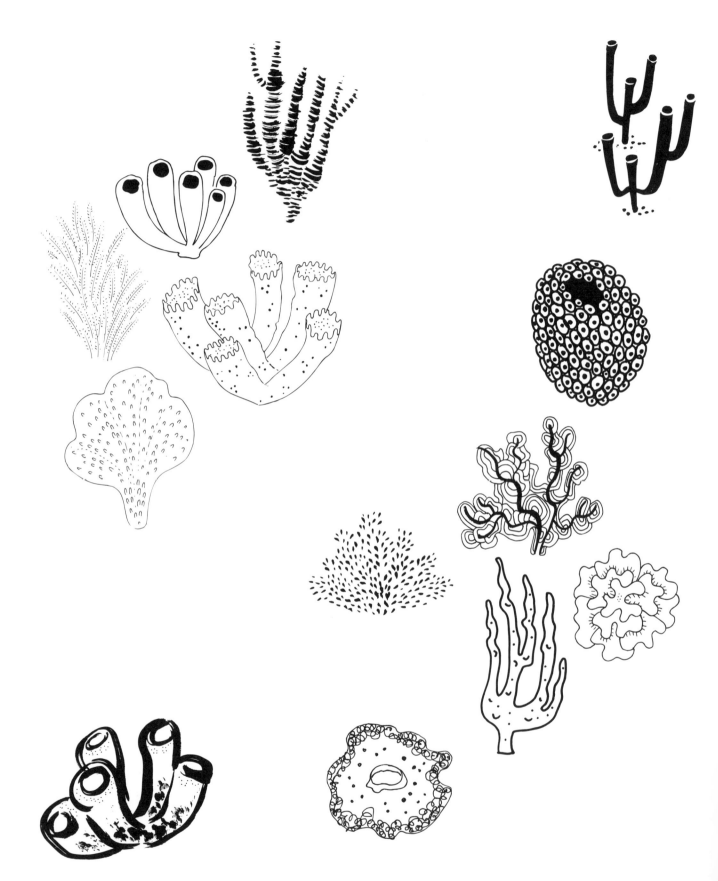

DRAW 20
sponges

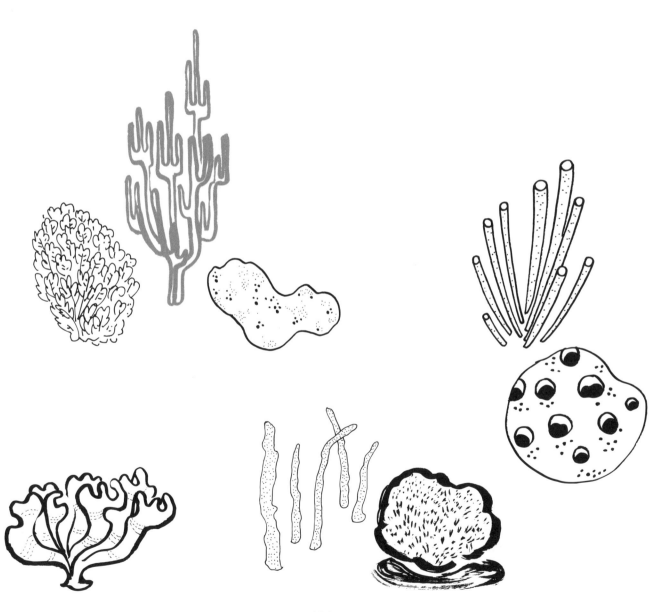

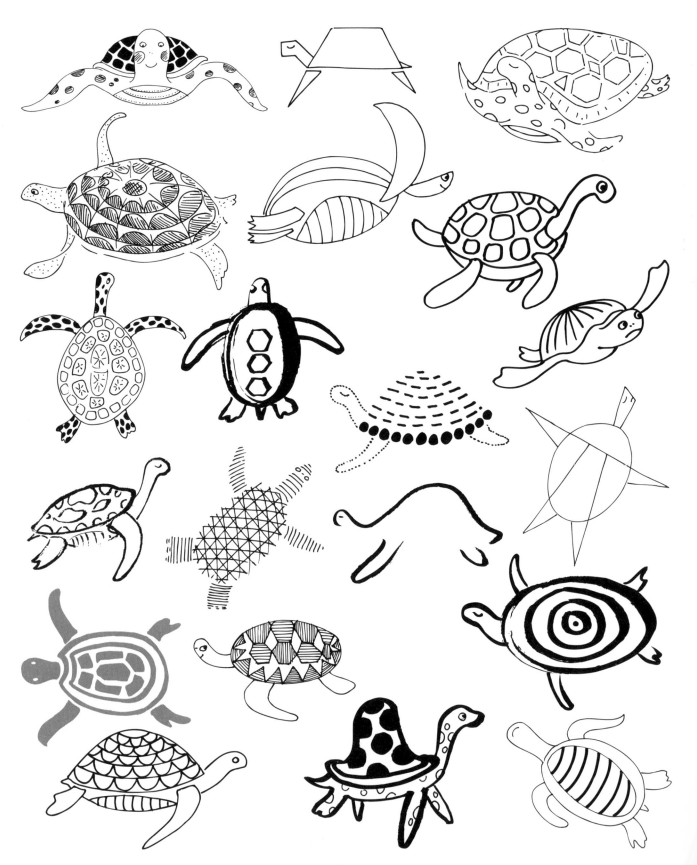

DRAW 20
SEA TURTLES

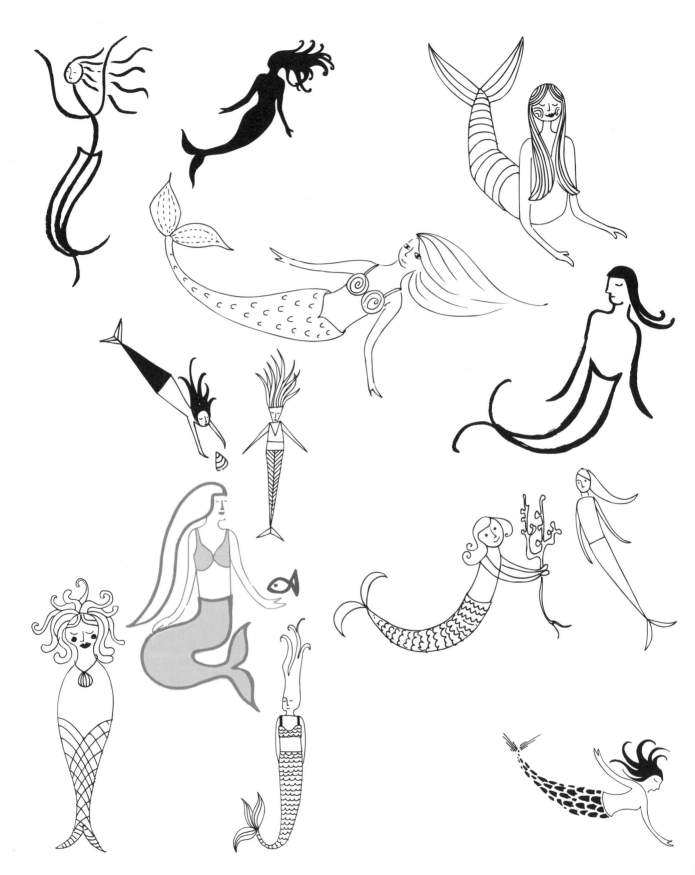

DRAW 20

MERMAIDS

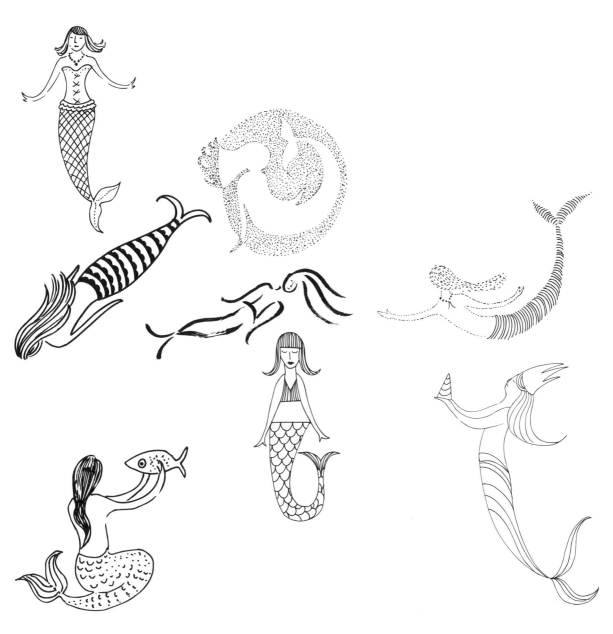

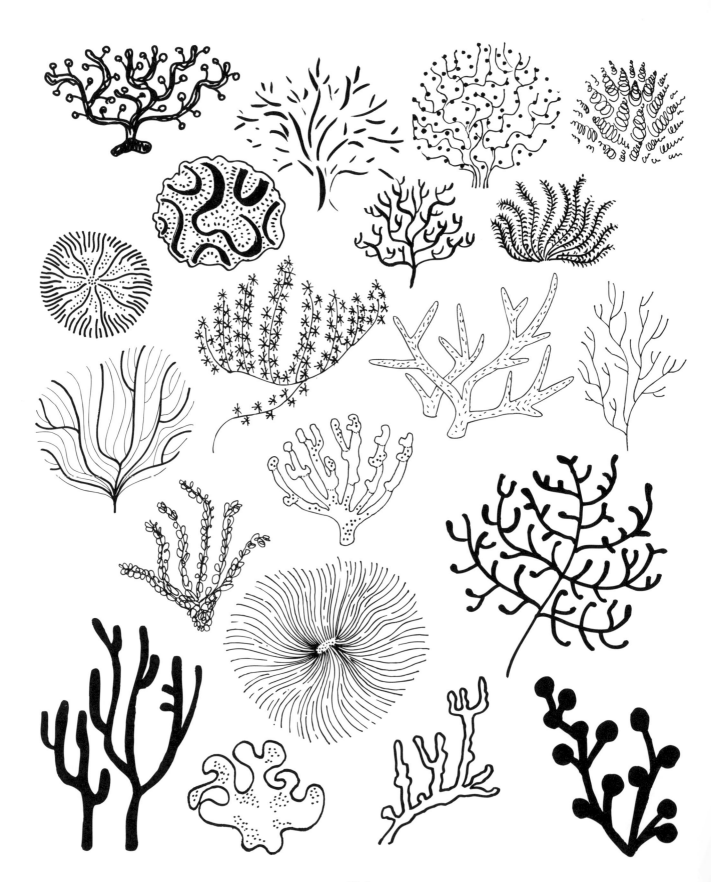

DRAW 20
Corals

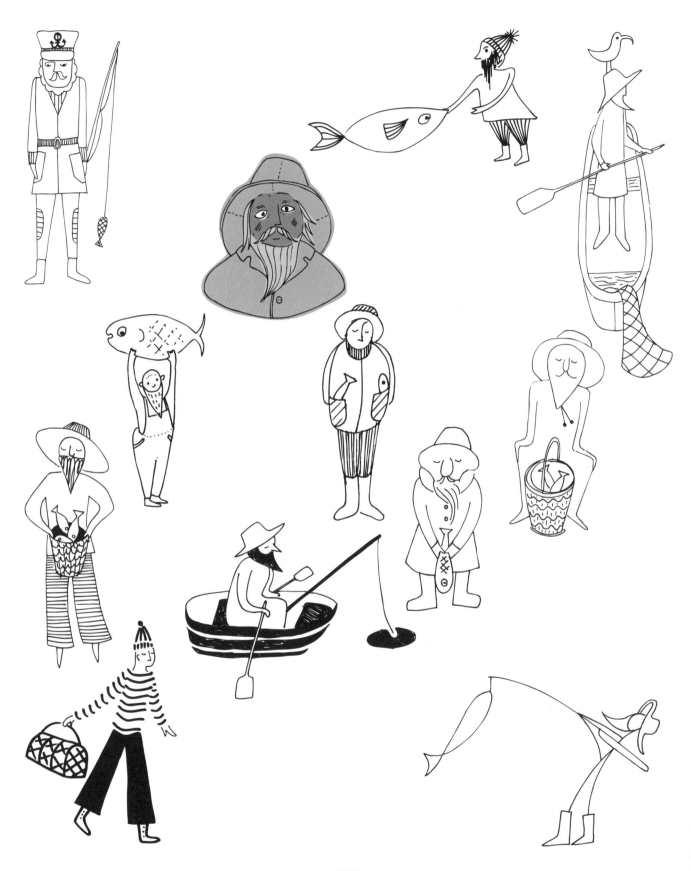

DRAW 20
FISHERMEN

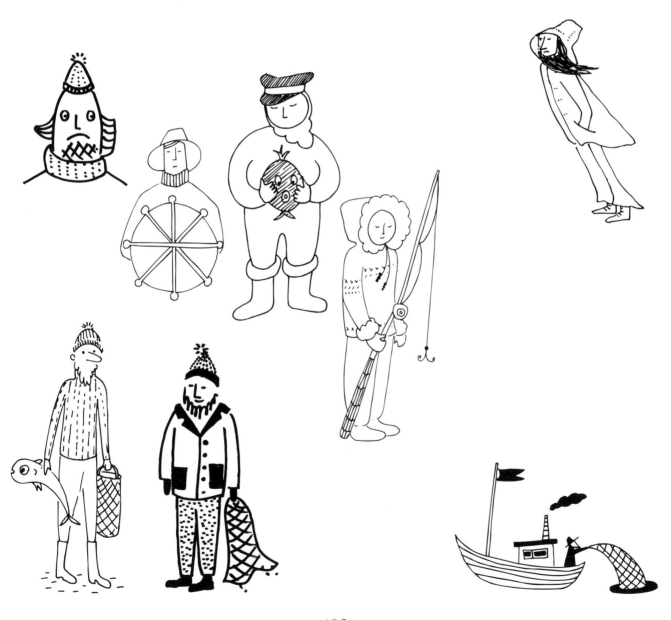

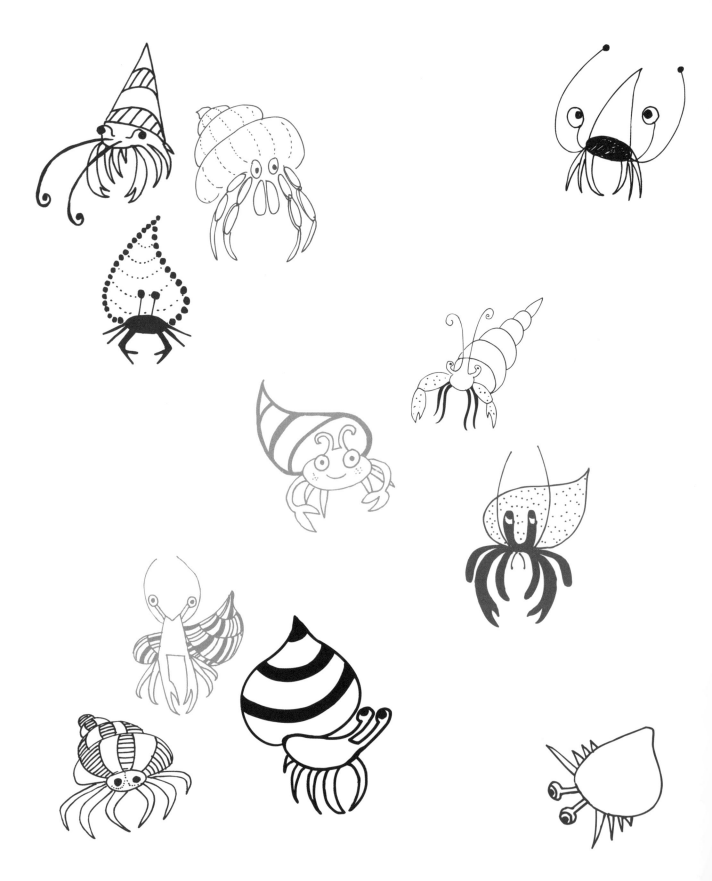

Hermit Crabs

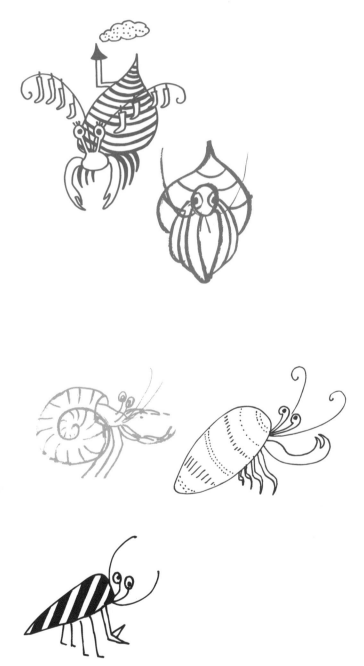
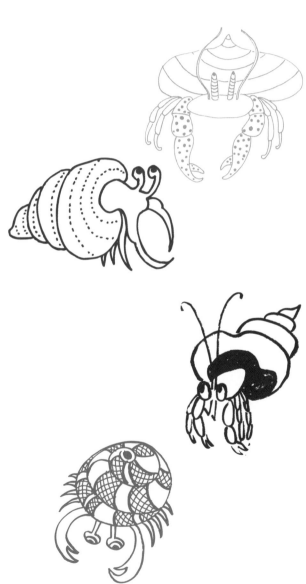

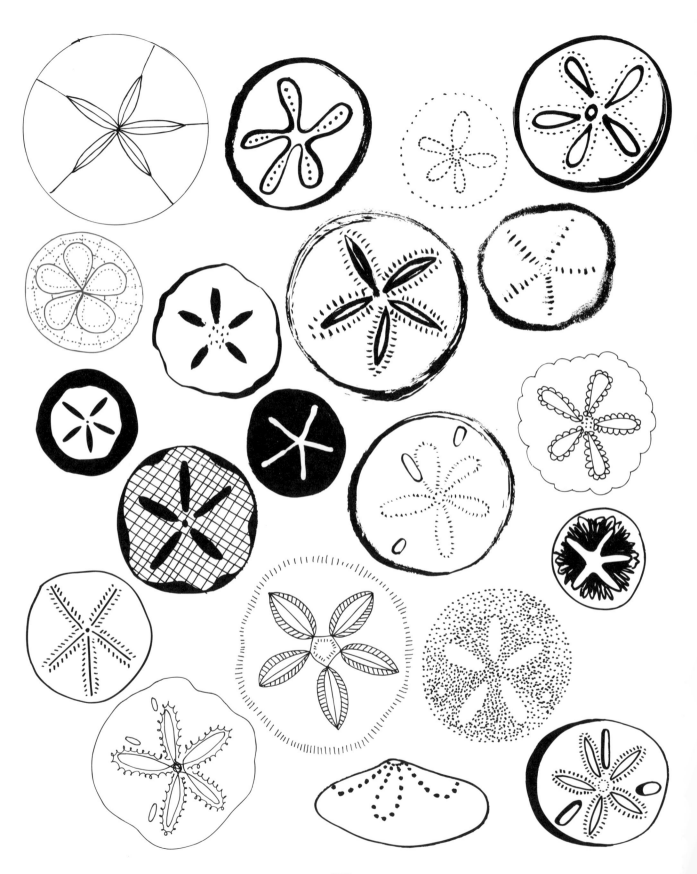

DRAW 20
SAND DOLLARS

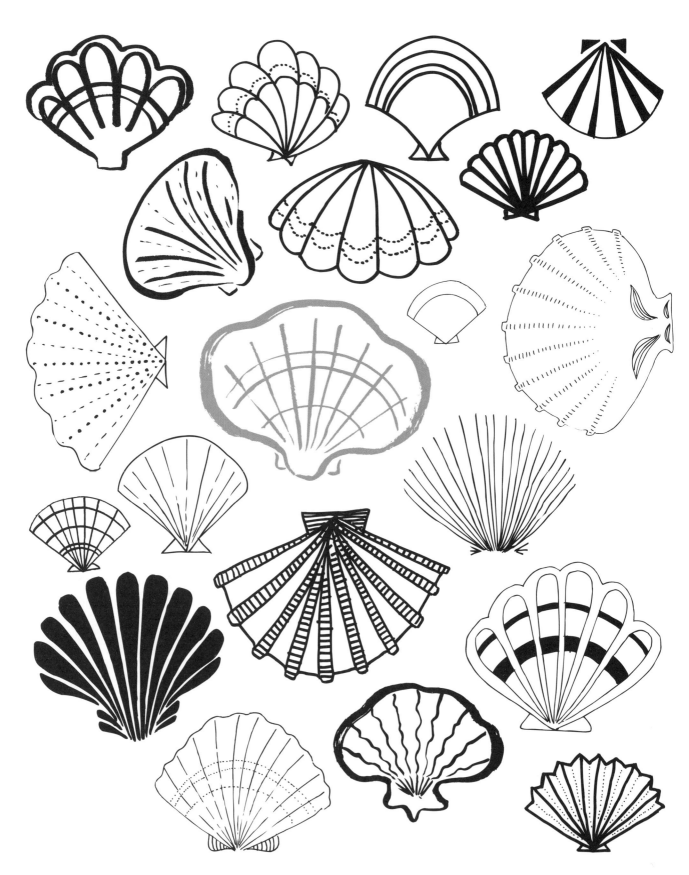

DRAW 20
scallops

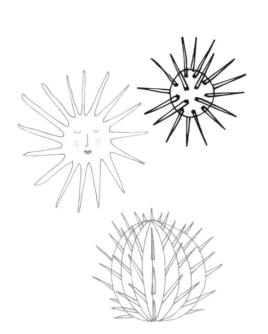
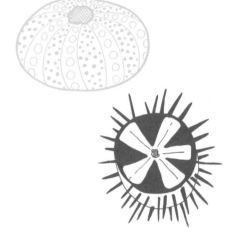
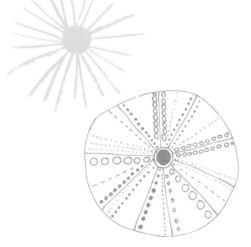

DRAW 20
Sea Urchins

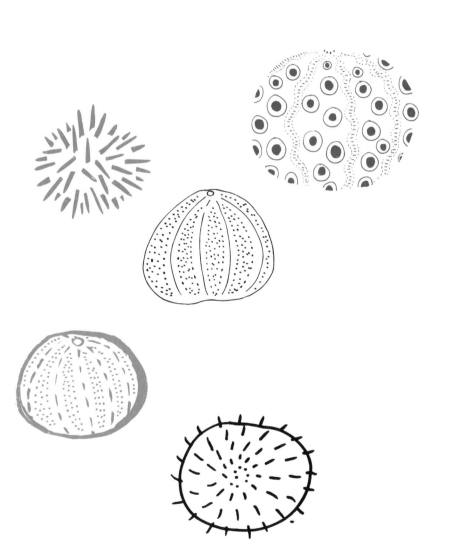

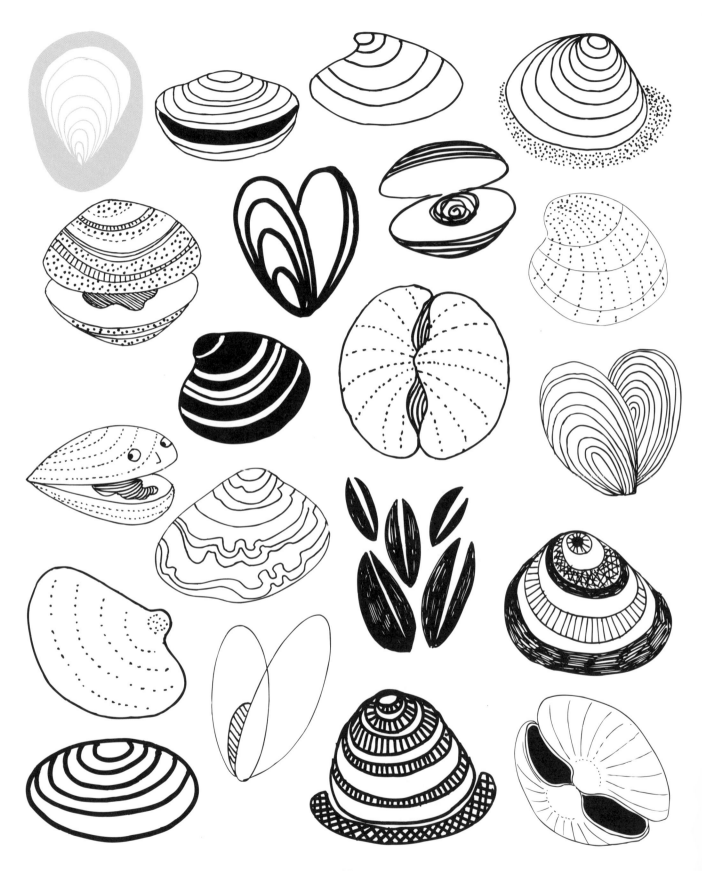

DRAW 20
Clams

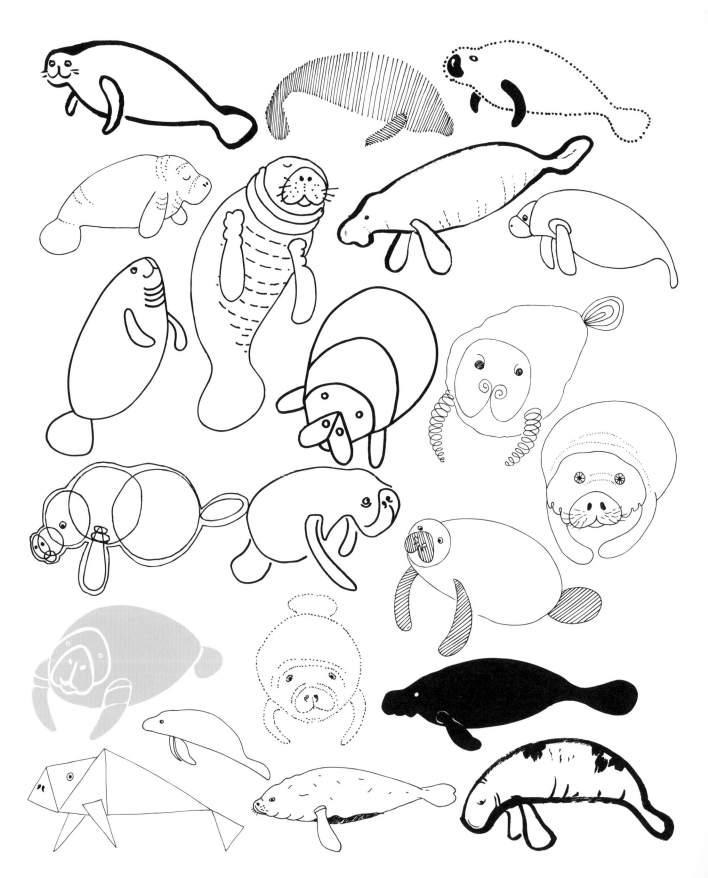

DRAW 20
manatees

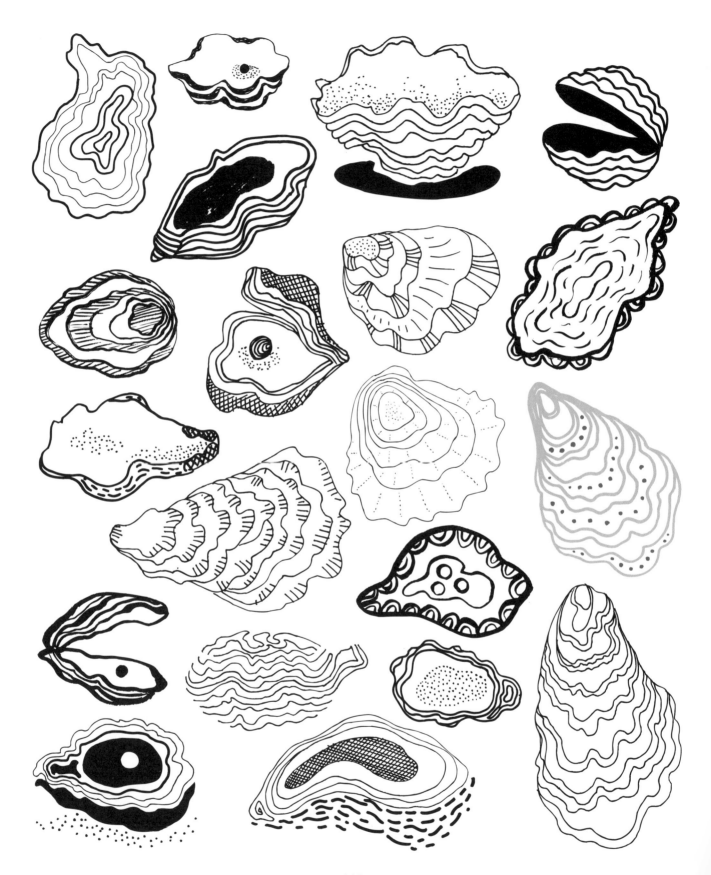

DRAW 20
OYSTERS

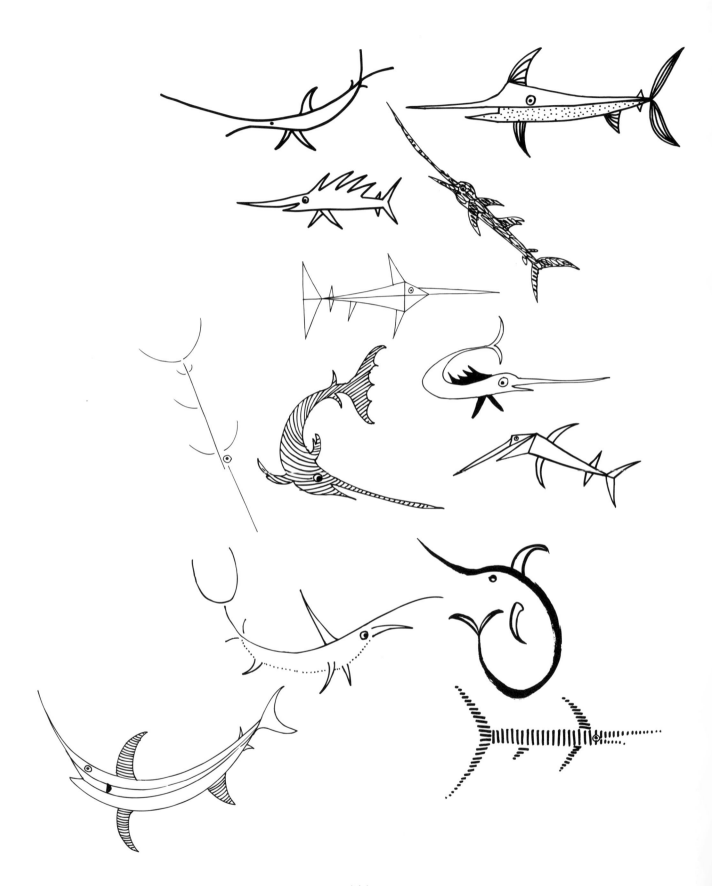

DRAW 20
Swordfish

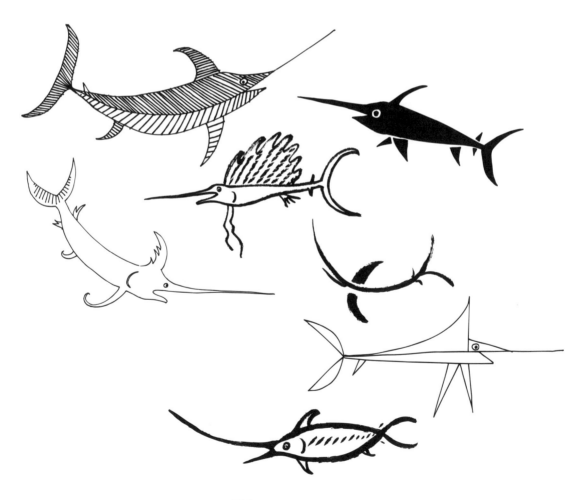

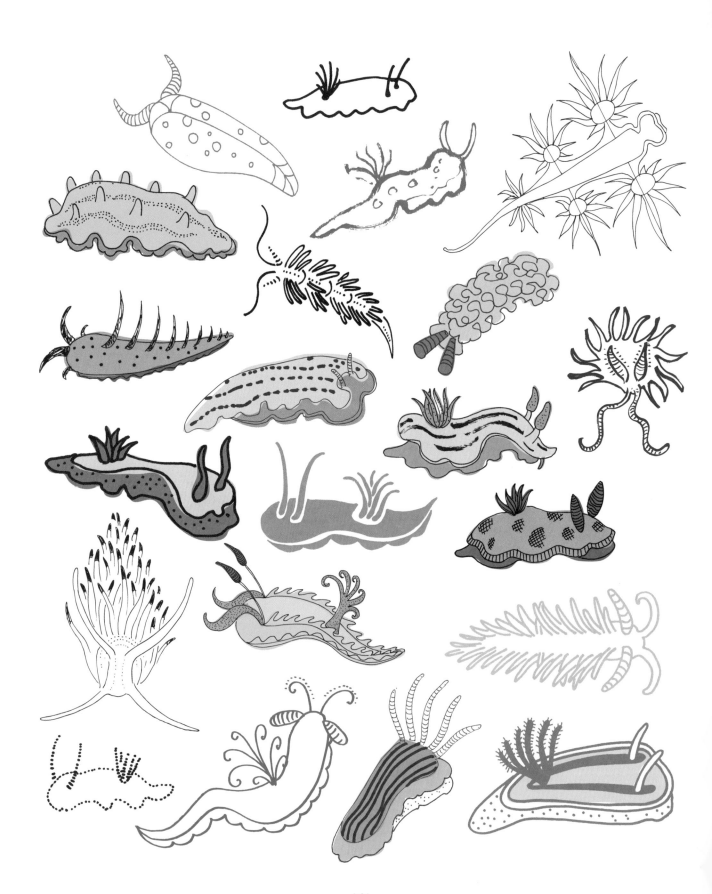

DRAW 20
Sea Slugs

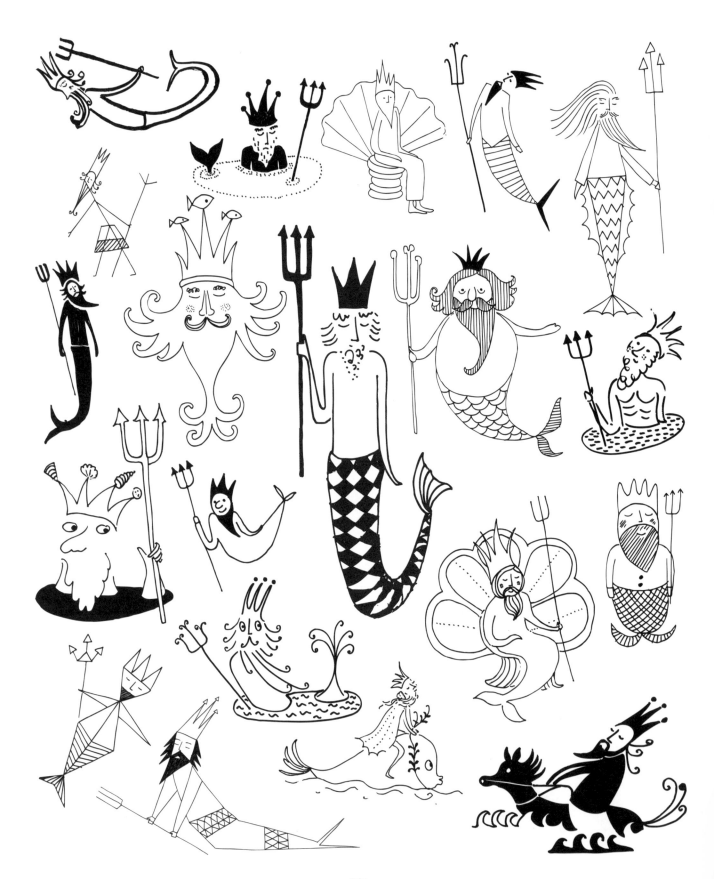

DRAW 20
KING NEPTUNES

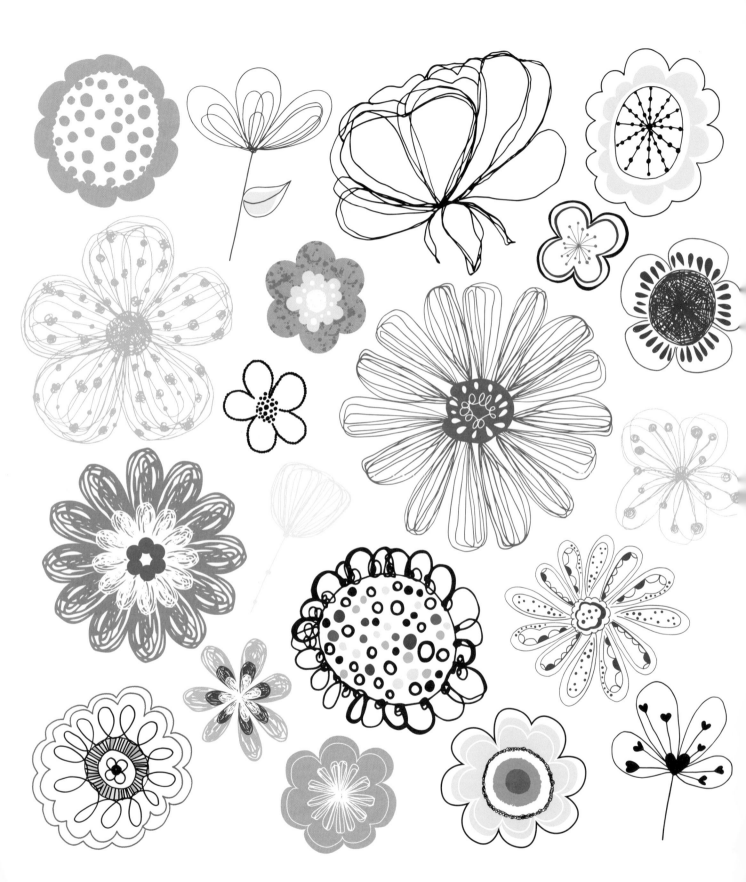

DRAW 20
FLOWERS

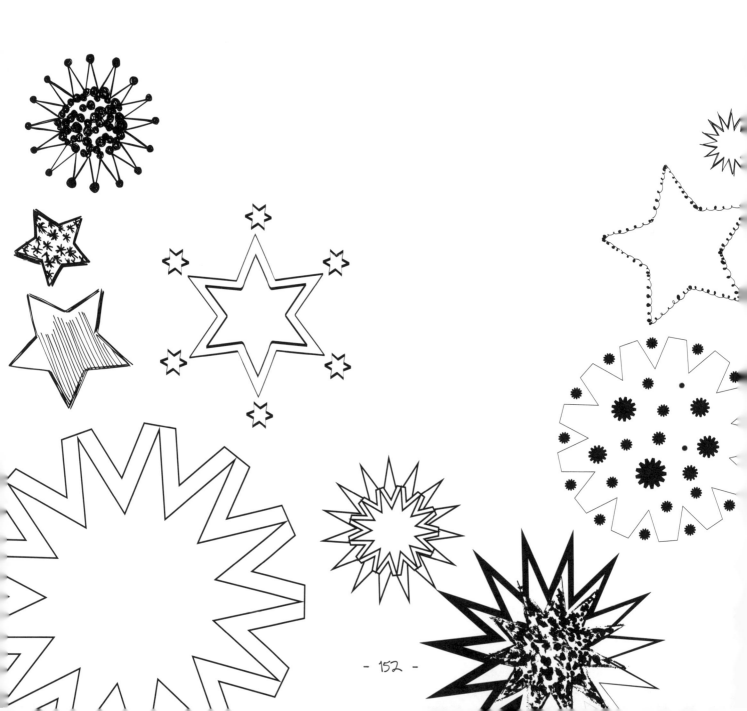

DRAW 20
STARS

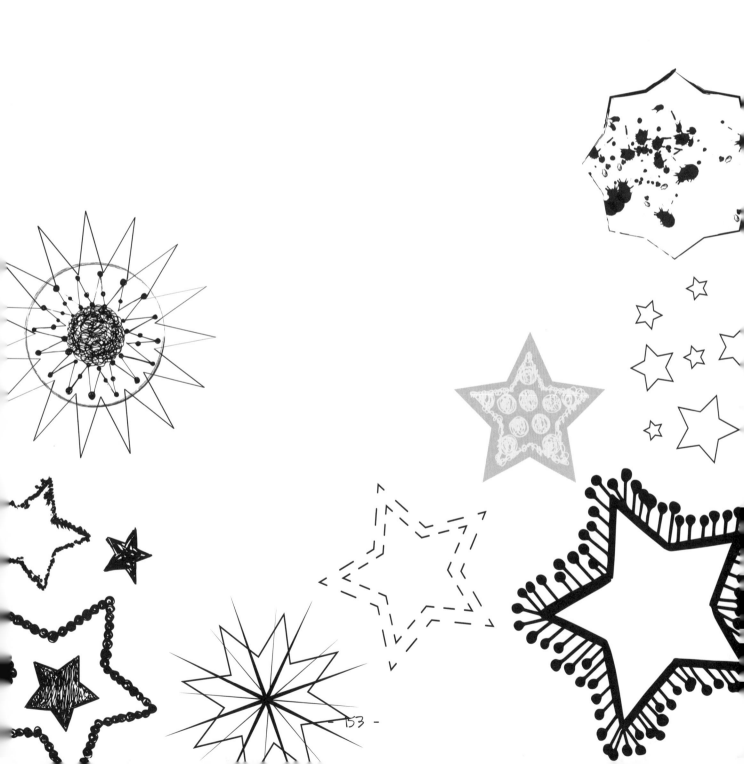

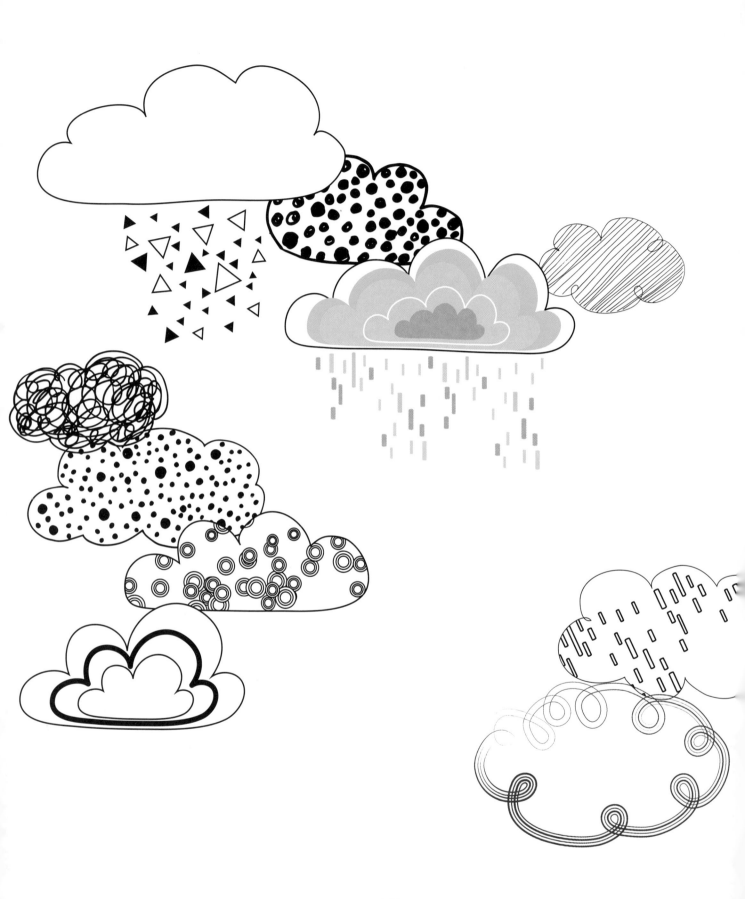

DRAW 20
CLOUDS

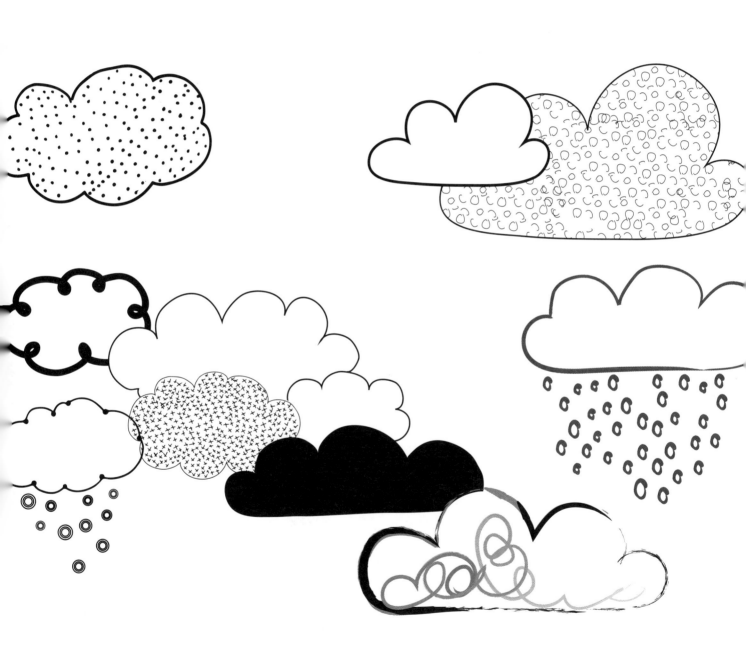

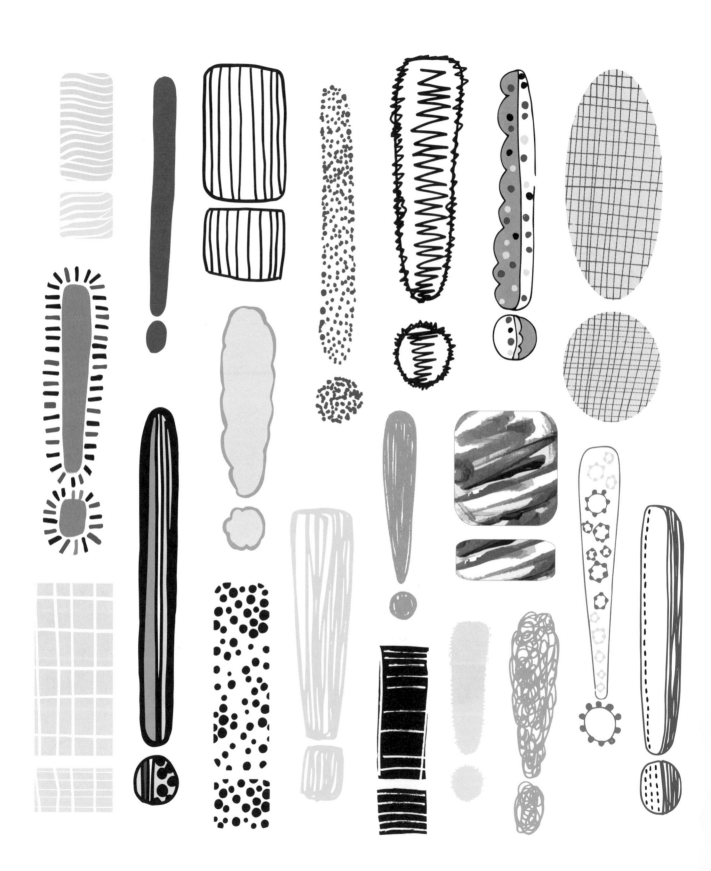

DRAW 20
EXCLAMATION POINTS

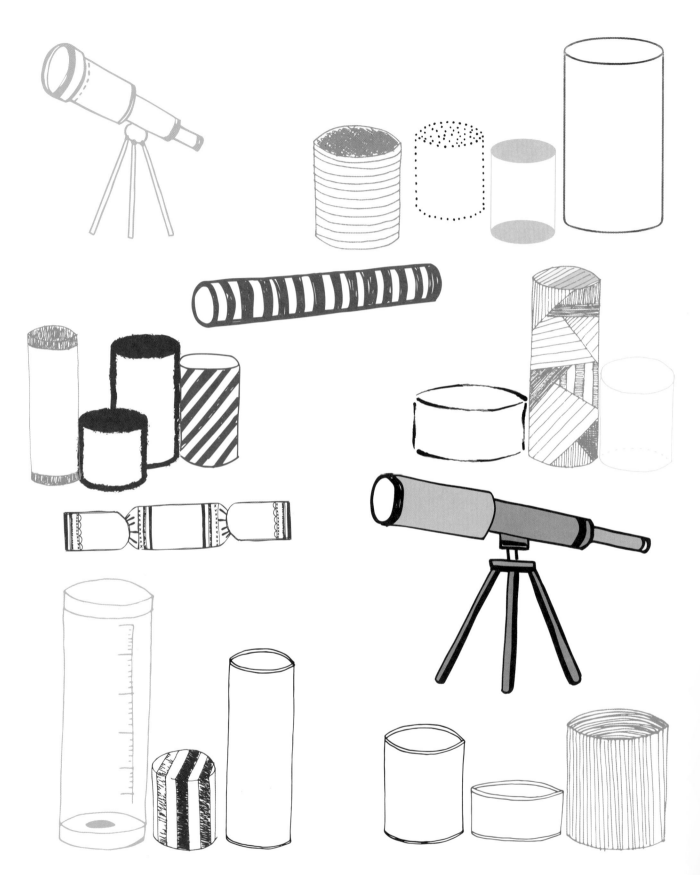

DRAW 20
cylinders

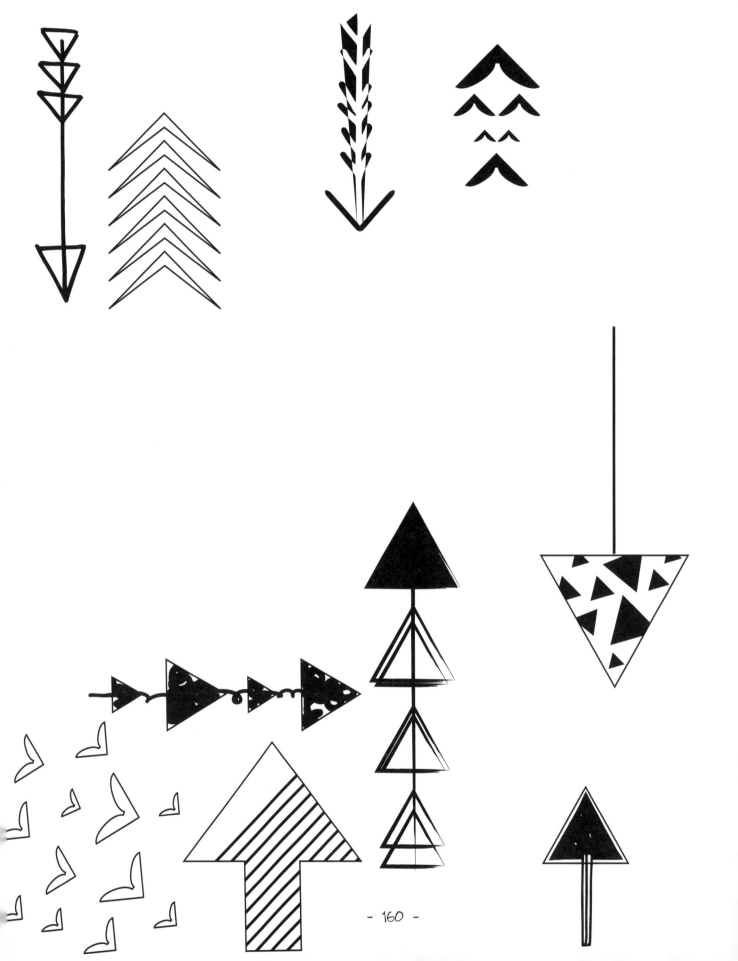

DRAW 20
arrows

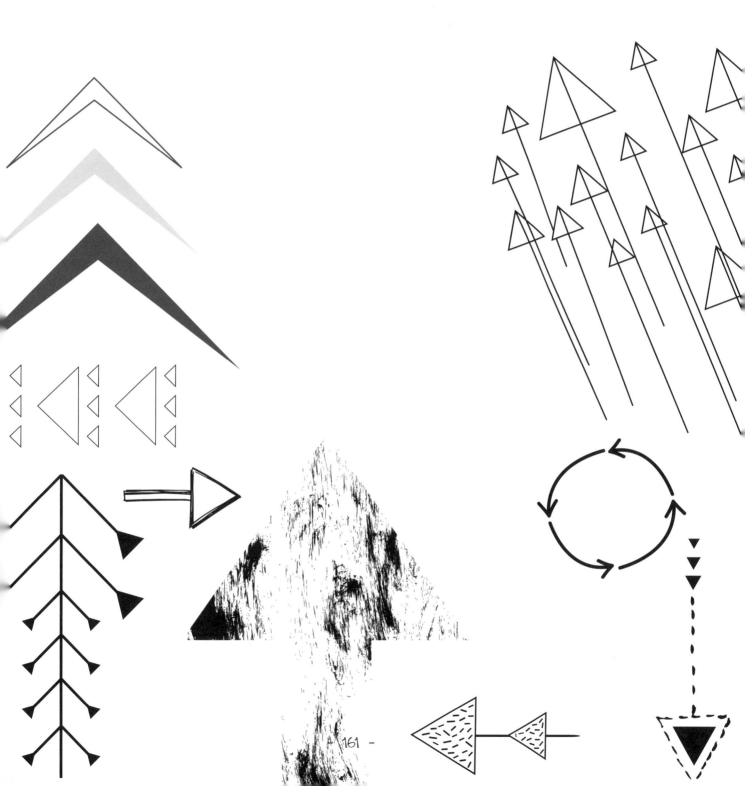

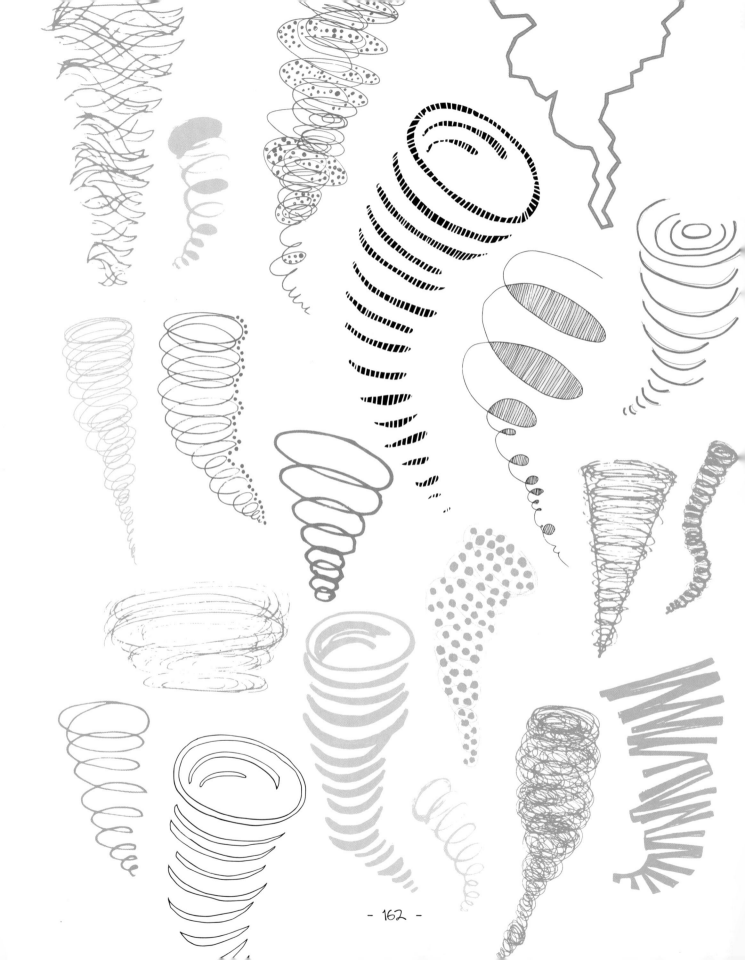

DRAW 20
Tornadoes

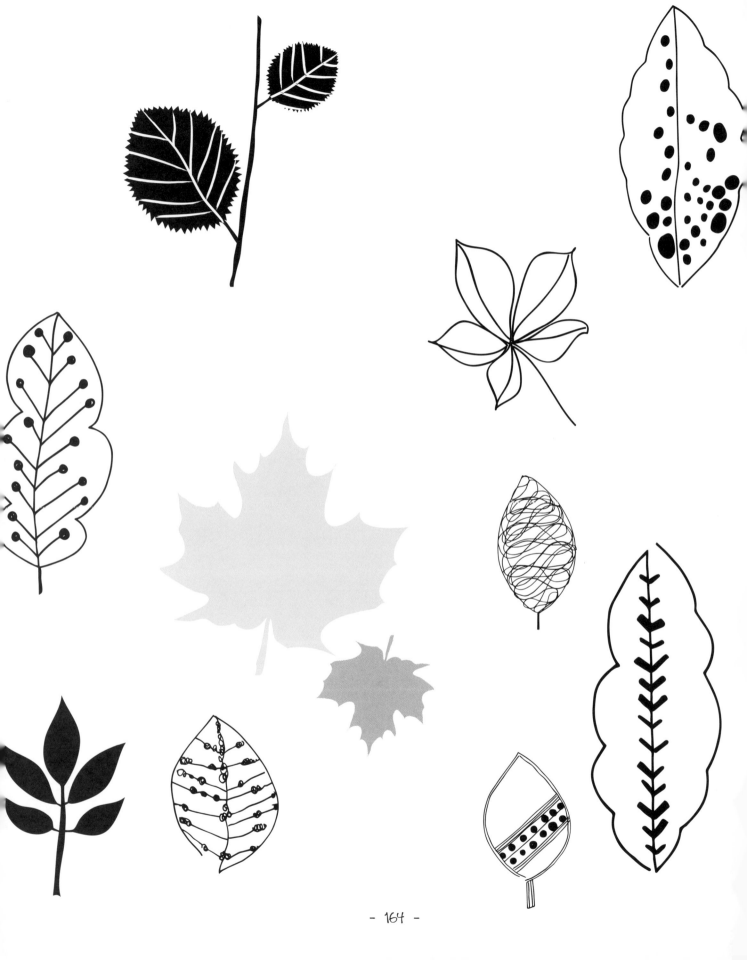

DRAW 20
Leaves

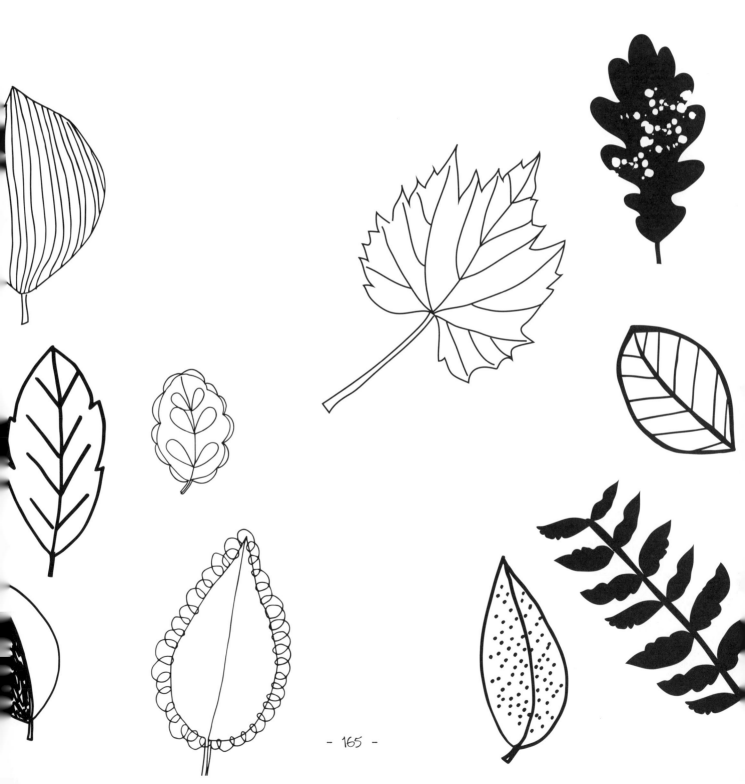

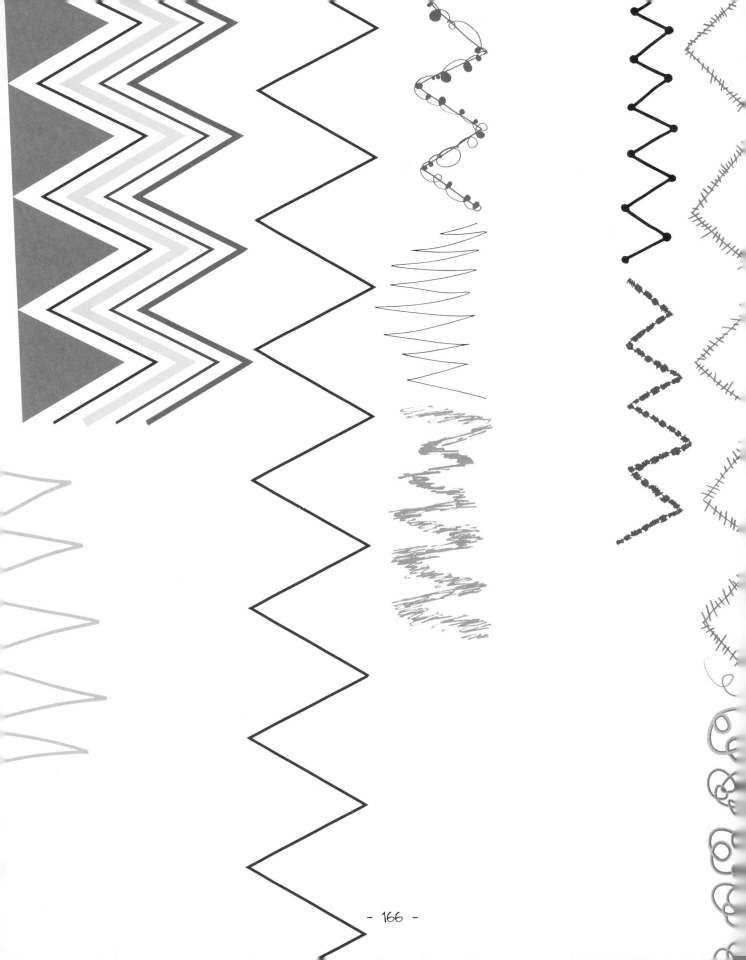

DRAW 20
ZIGZAGS

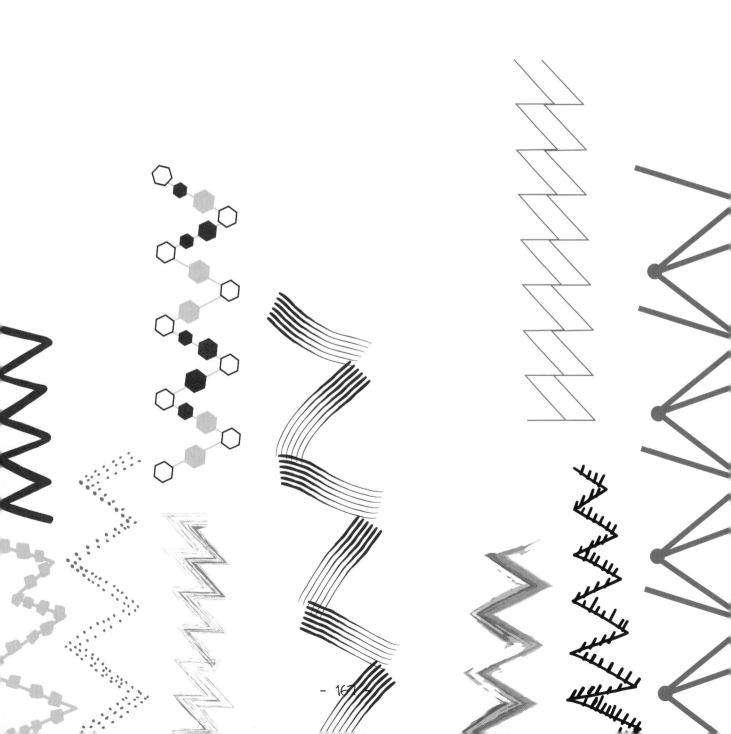

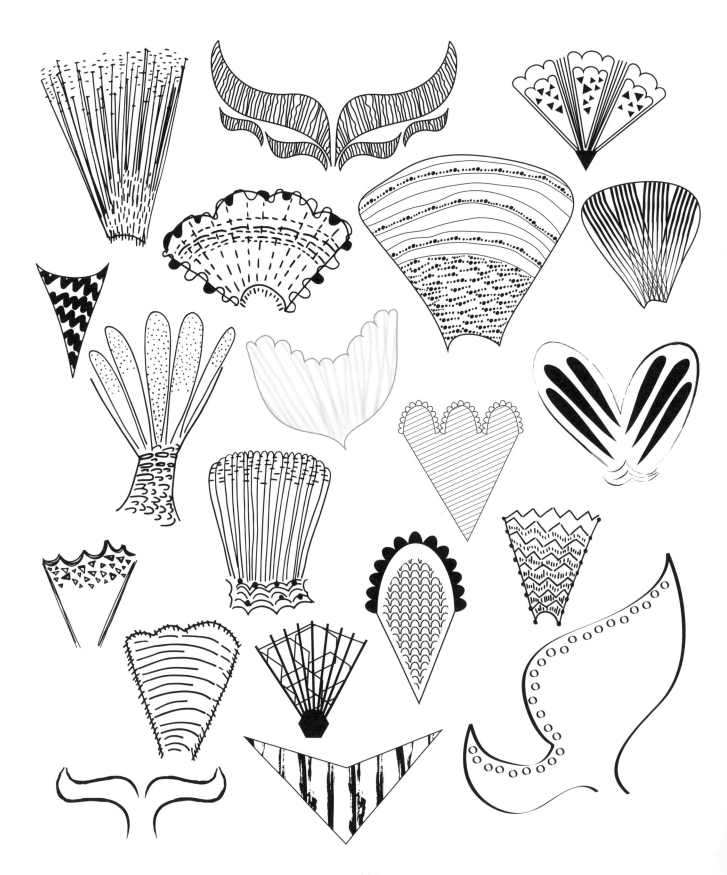

DRAW 20
FISH TAILS

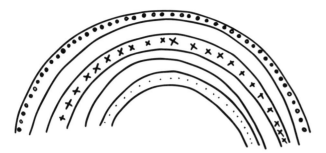

DRAW 20
rainbows

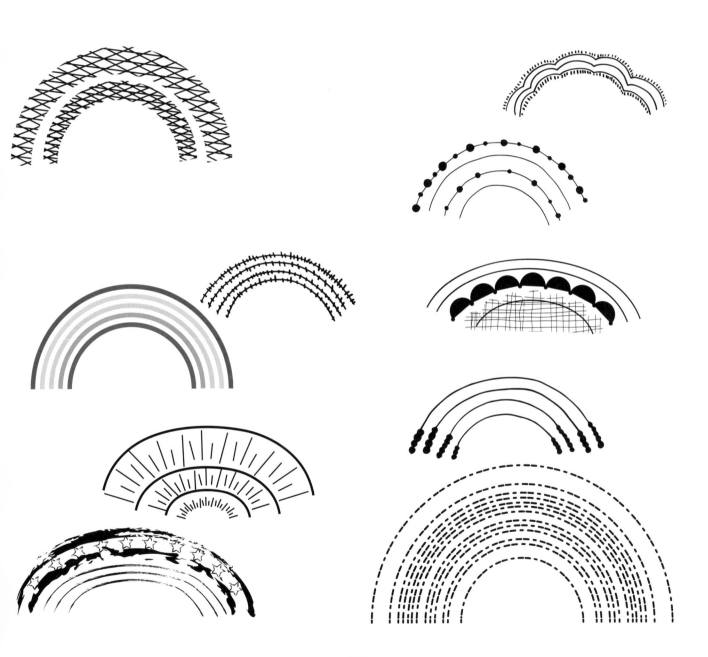

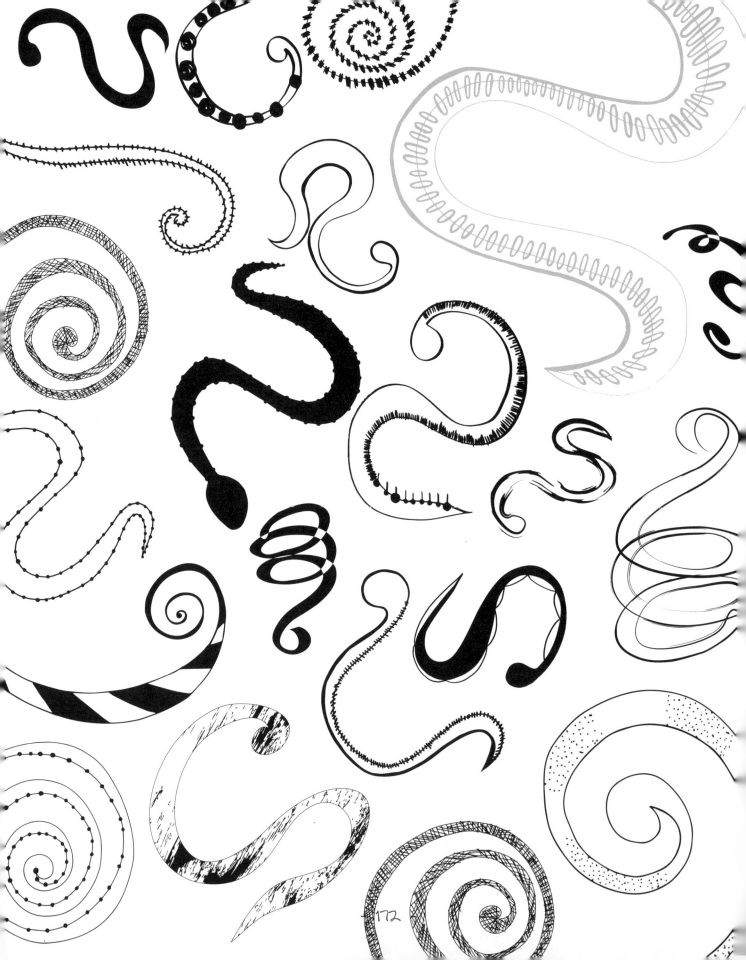

DRAW 20
SNAKES

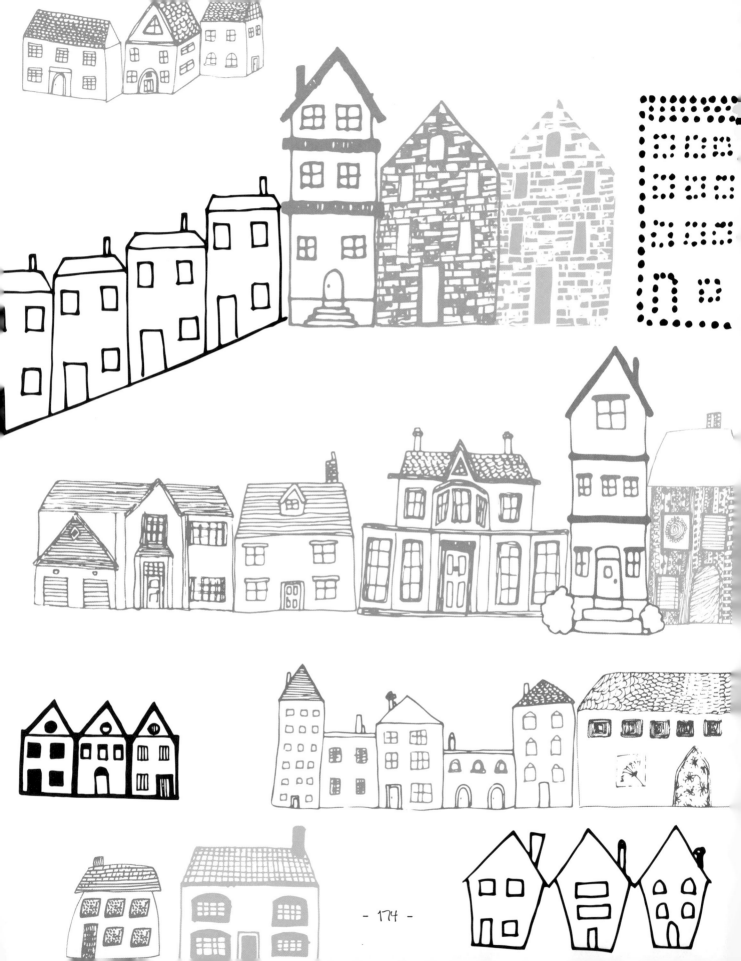

DRAW 20
HOUSES

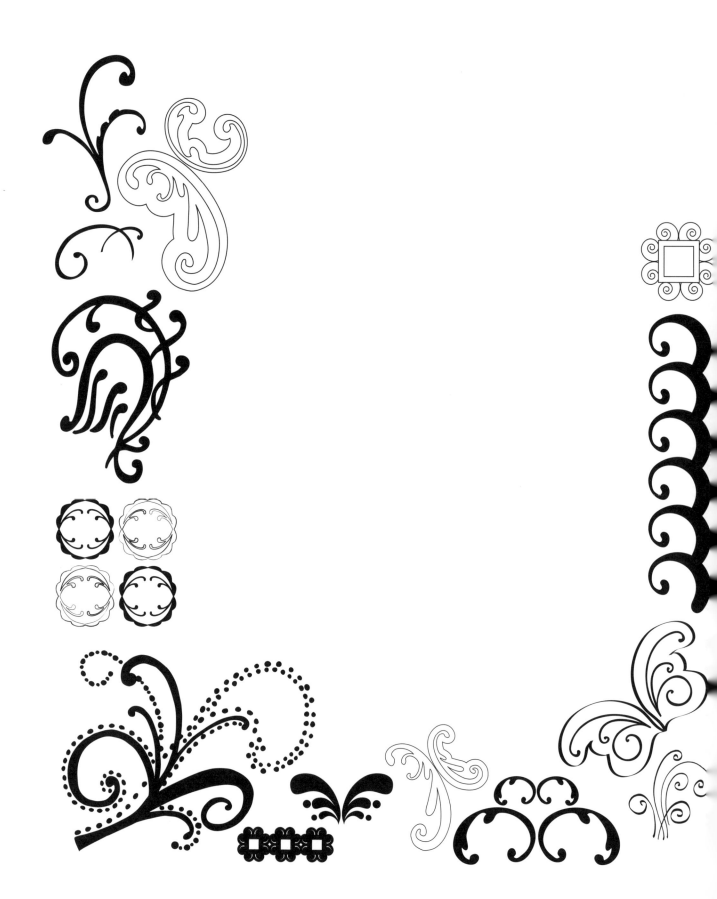

DRAW 20
flourishes

DRAW 20
HEARTS

DRAW 20
spirals

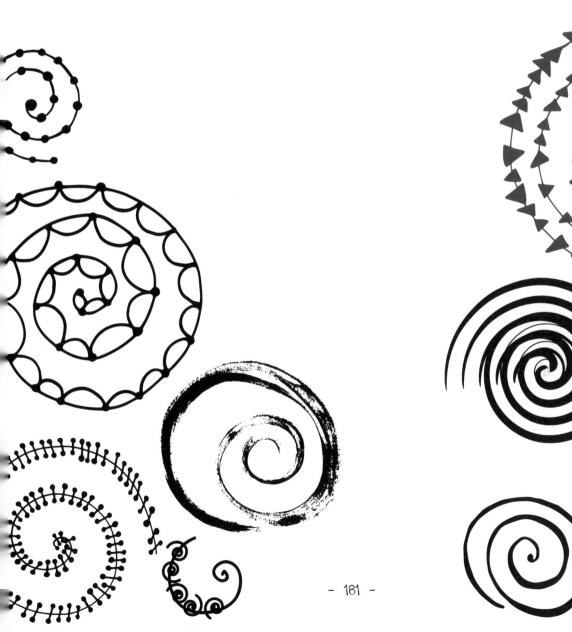
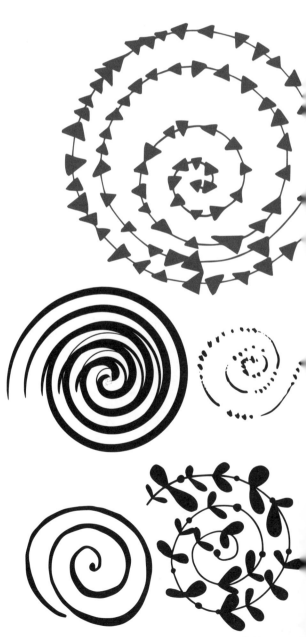

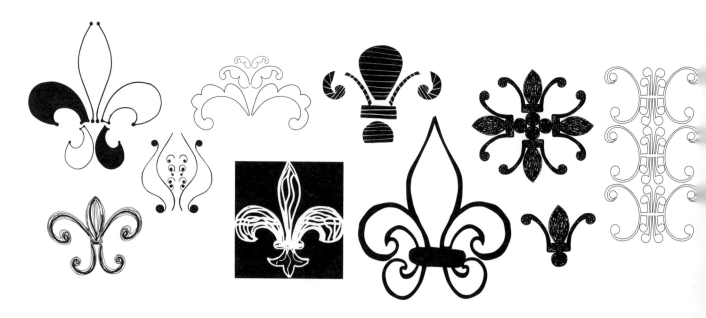

DRAW 20
Fleur~de~lis

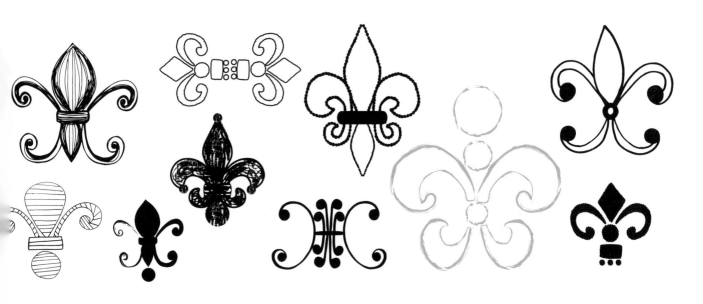

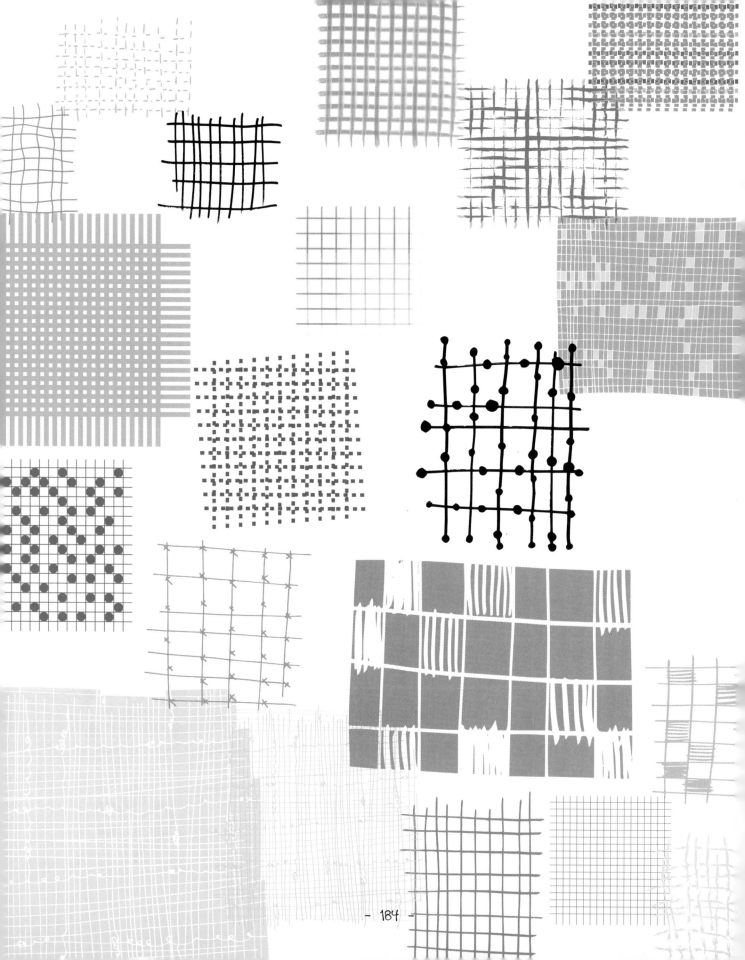

- 184 -

DRAW 20
CROSSHATCHES

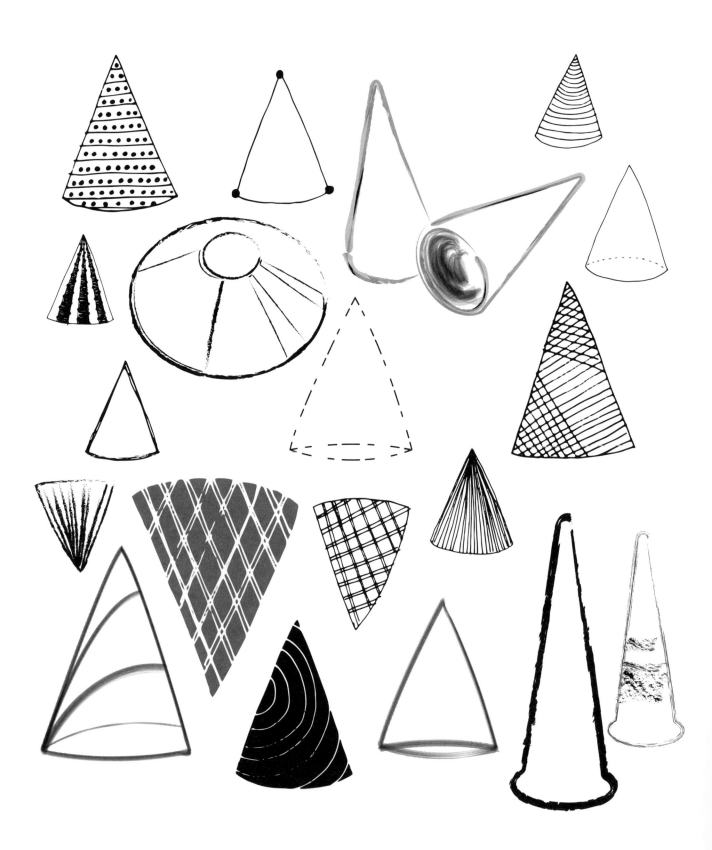

DRAW 20
CONES

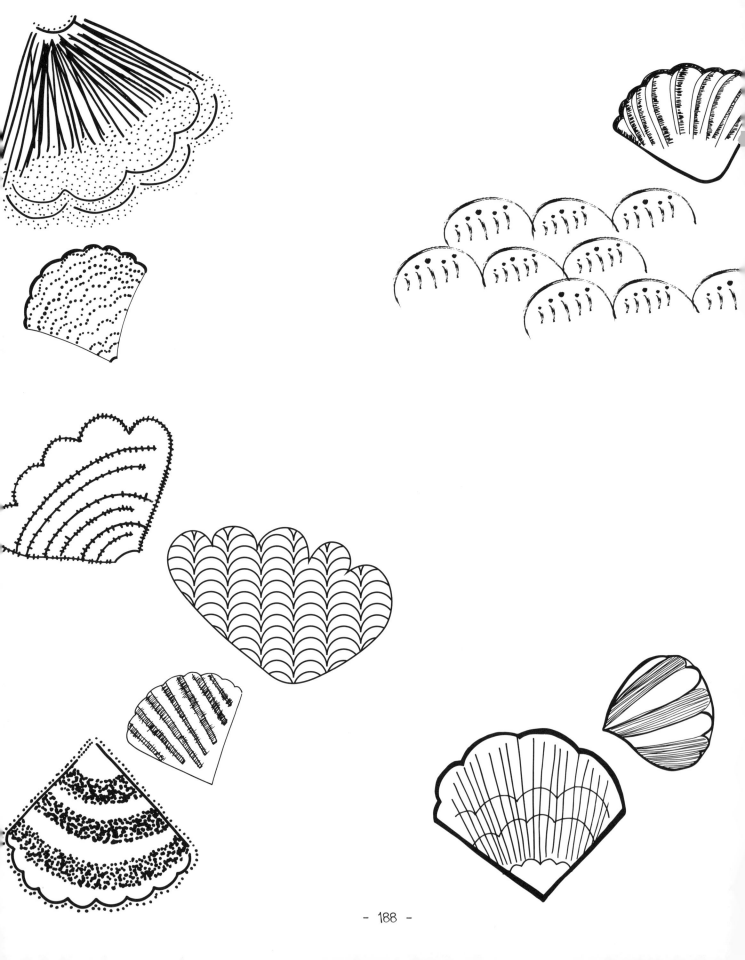

DRAW 20
SCALLOPS

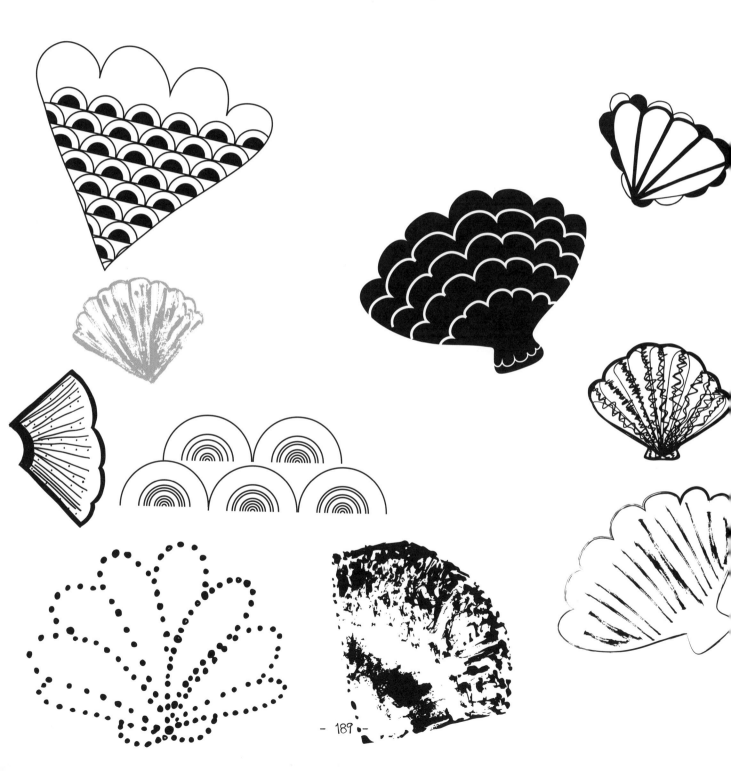

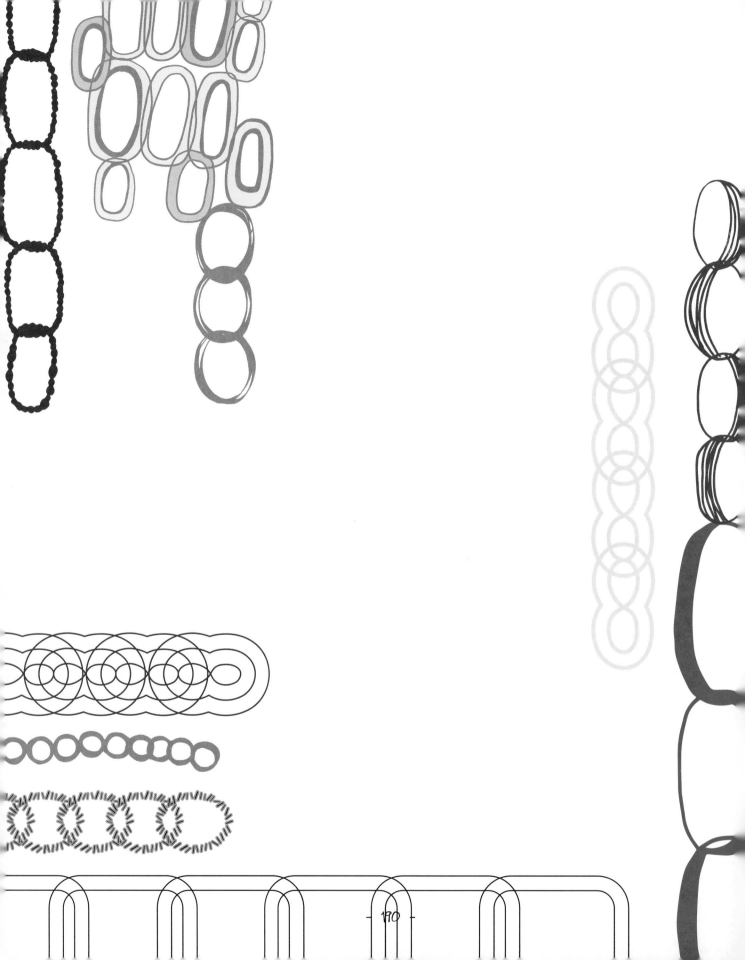

DRAW 20
Loops

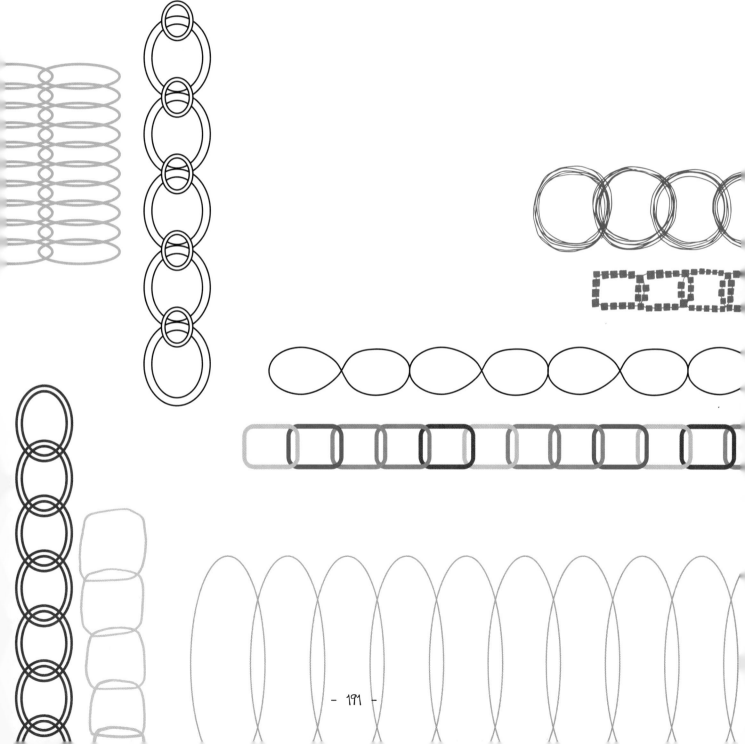

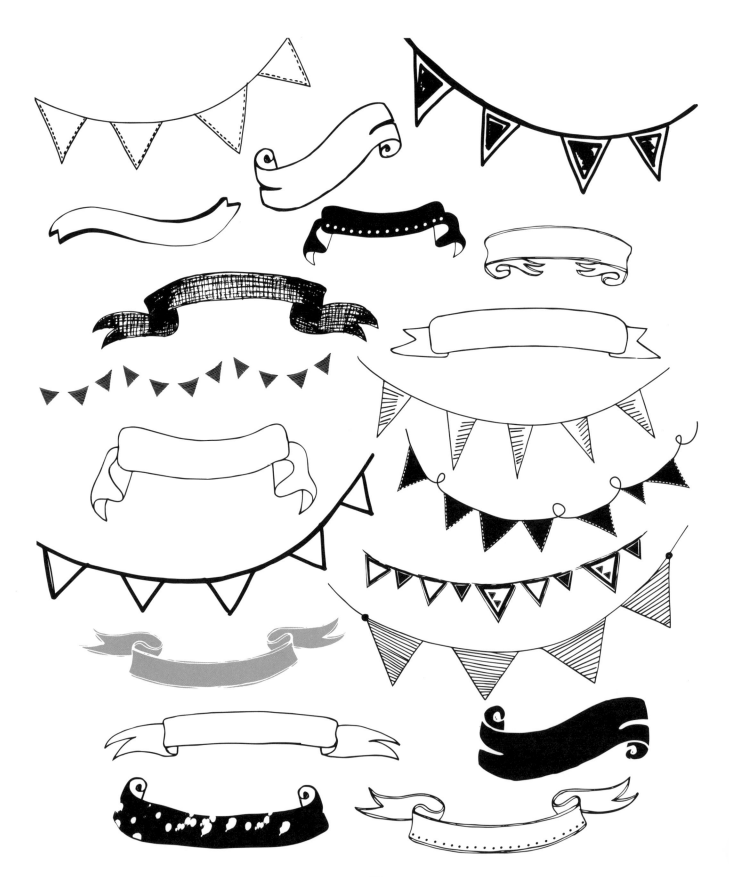

DRAW 20
BANNERS

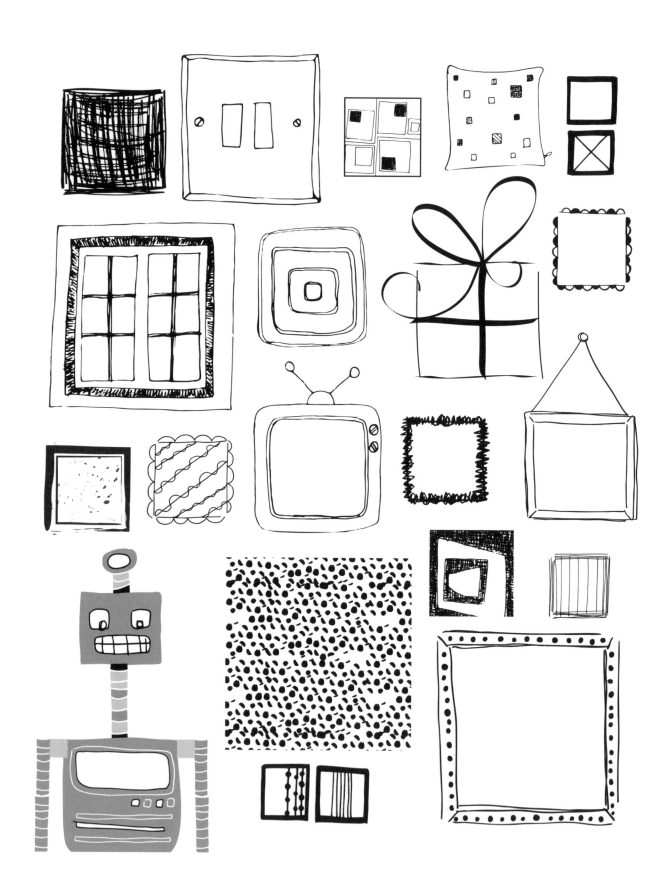

DRAW 20
squares

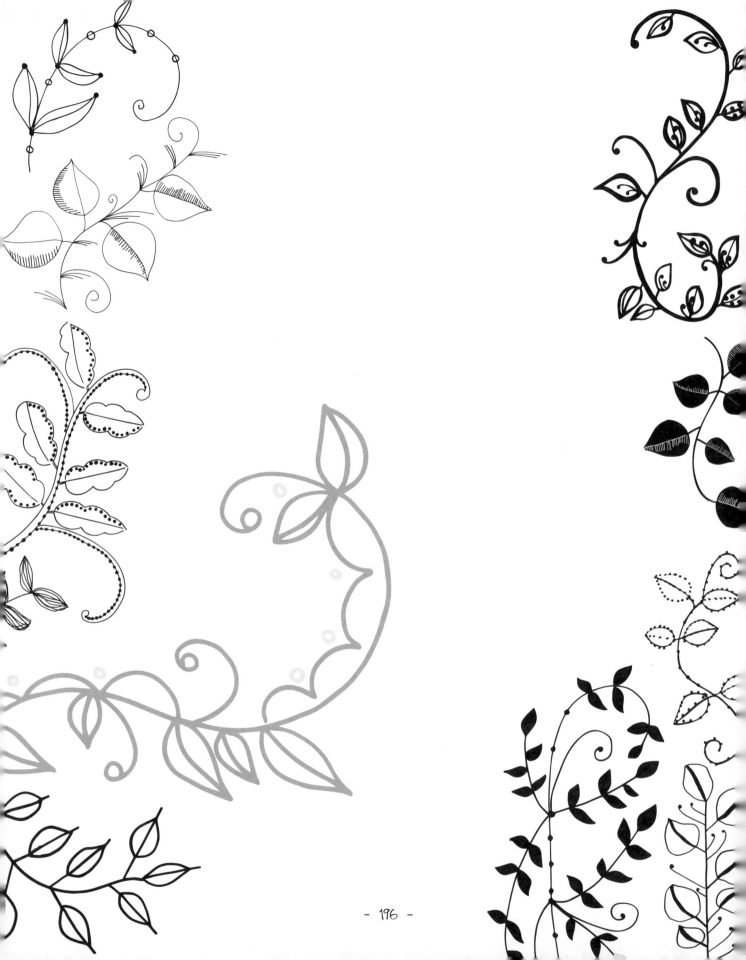

DRAW 20
VINES

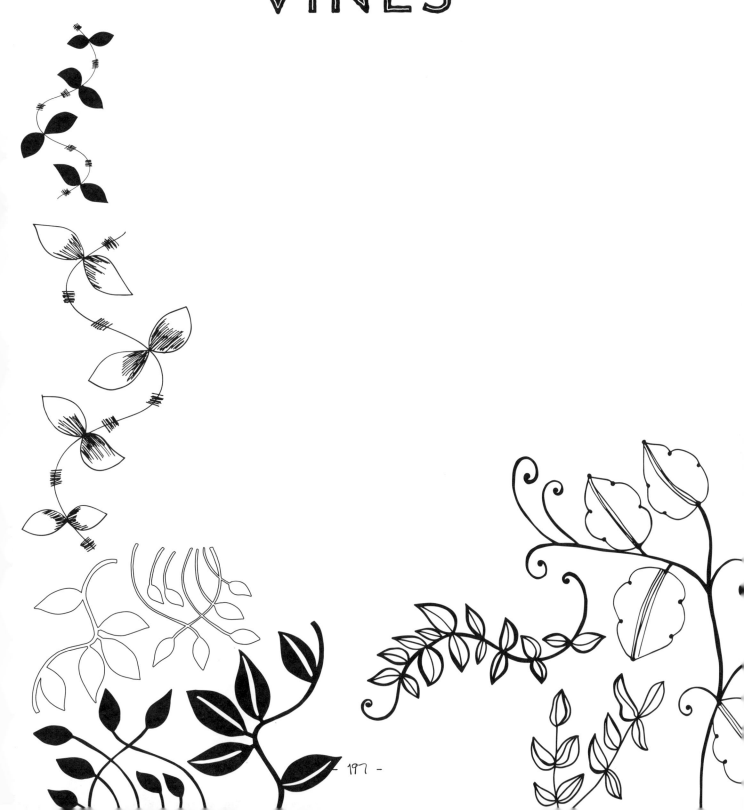

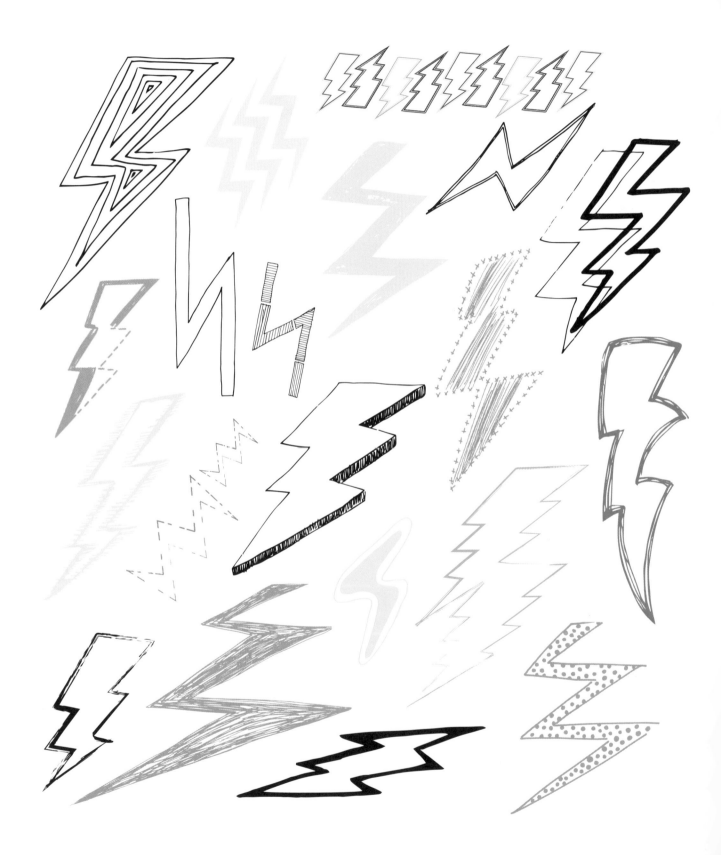

DRAW 20
LIGHTNING BOLTS

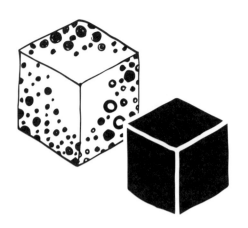

DRAW 20

CUBES

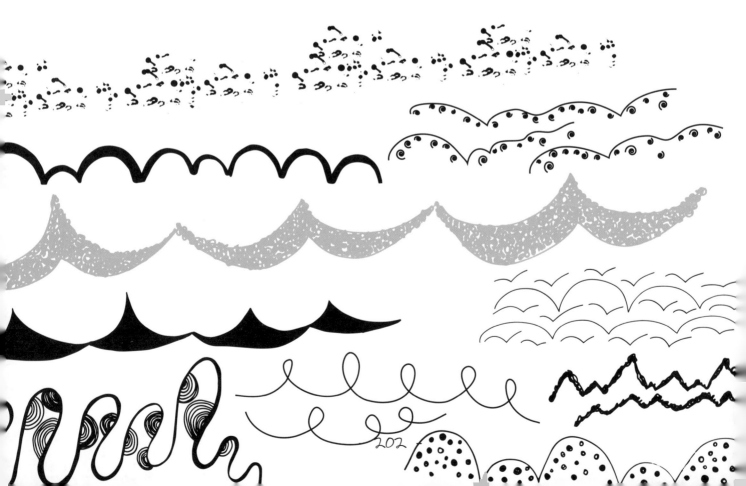

202

DRAW 20
Waves

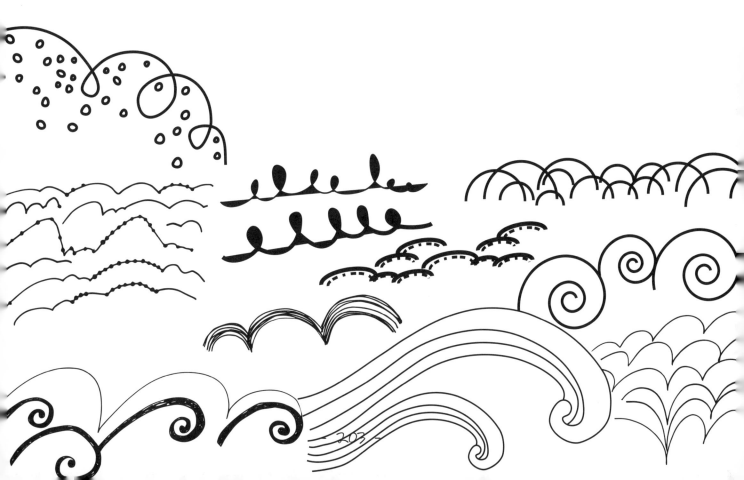

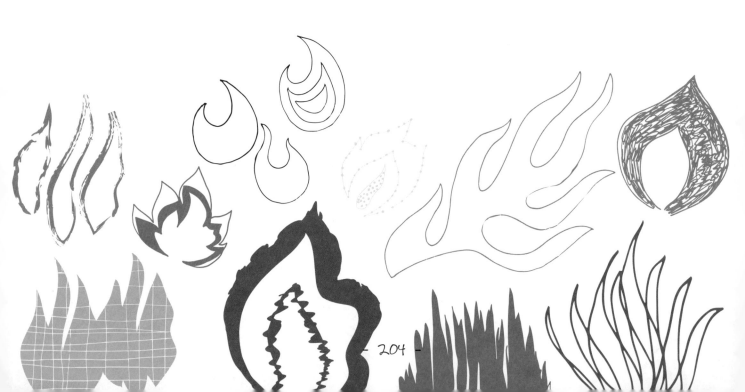

204

DRAW 20
FLAMES

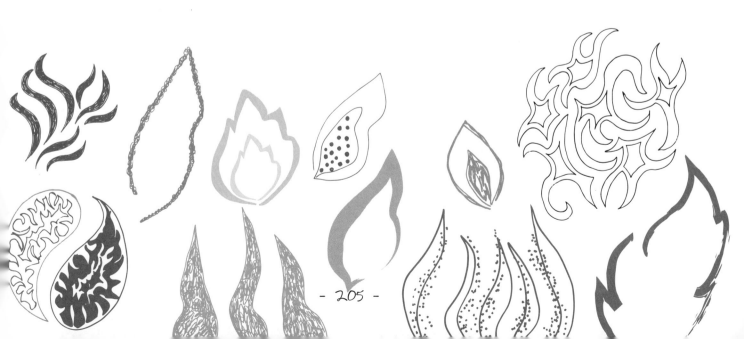

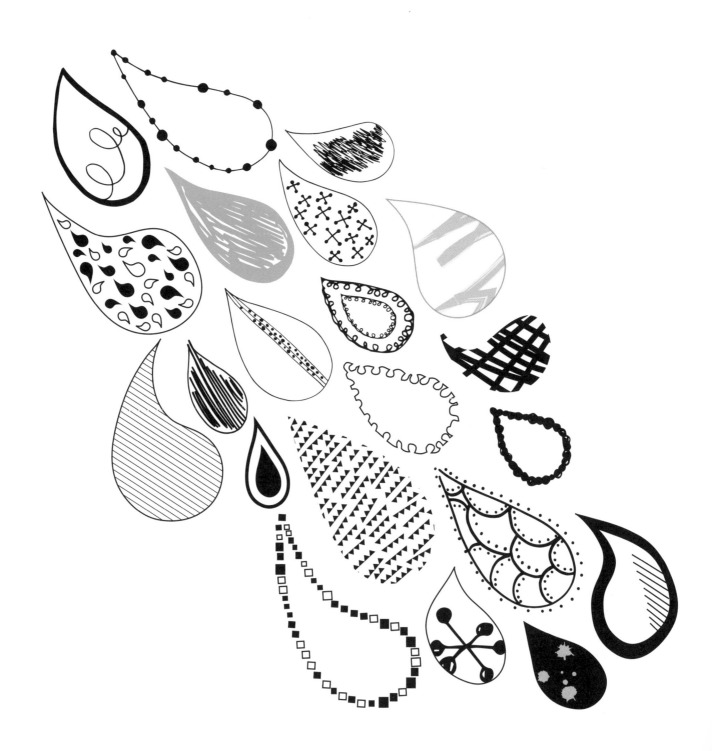

DRAW 20
Teardrops

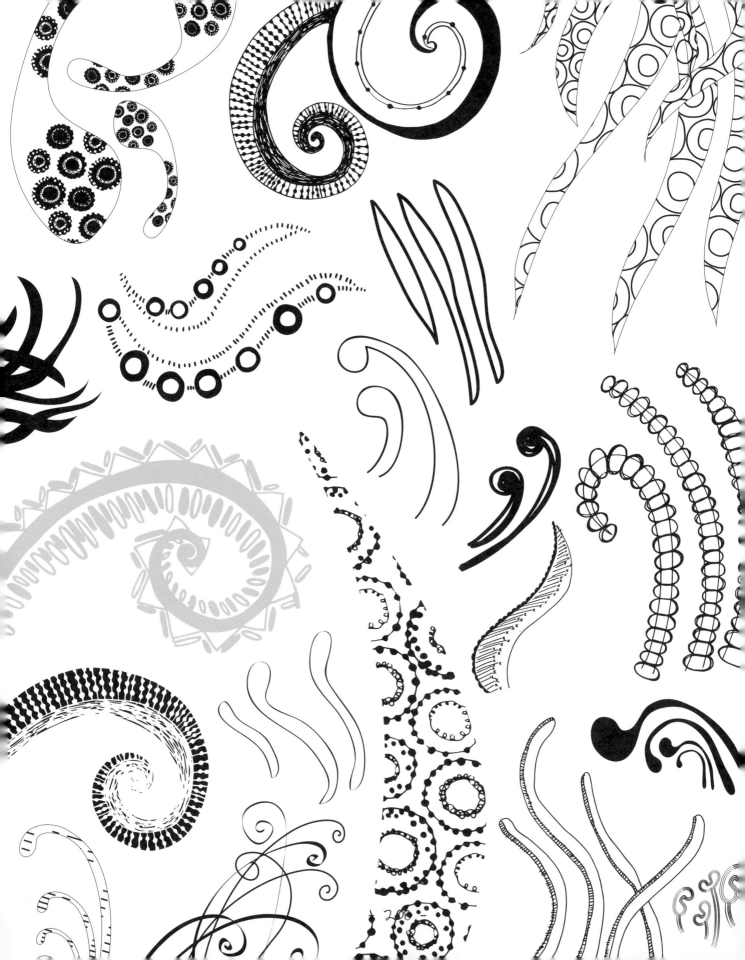

DRAW 20
Tentacles

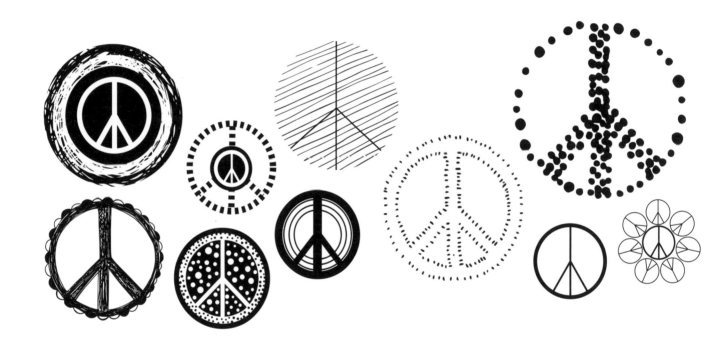

DRAW 20
Peace Signs

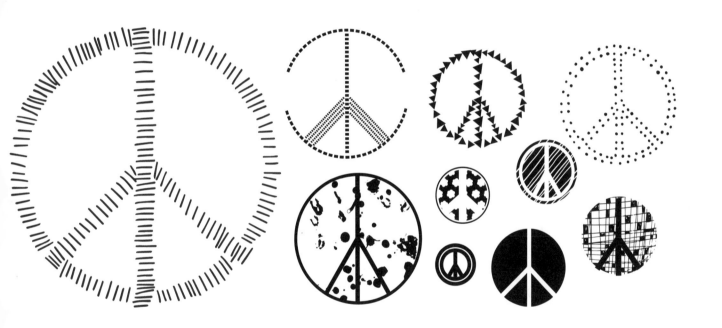

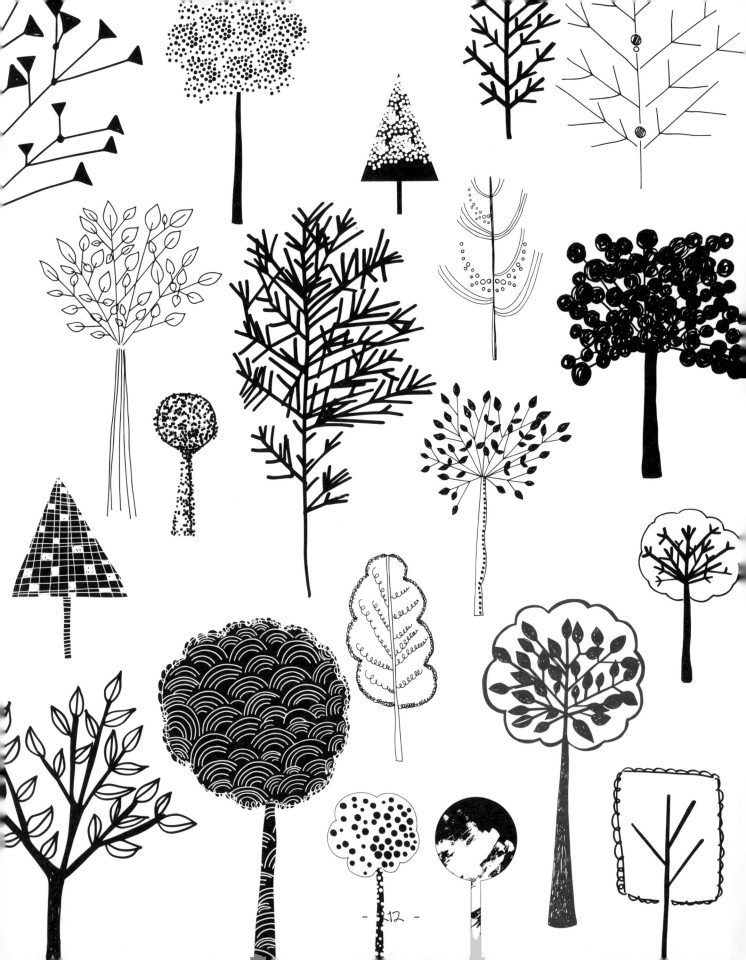

DRAW 20
Trees

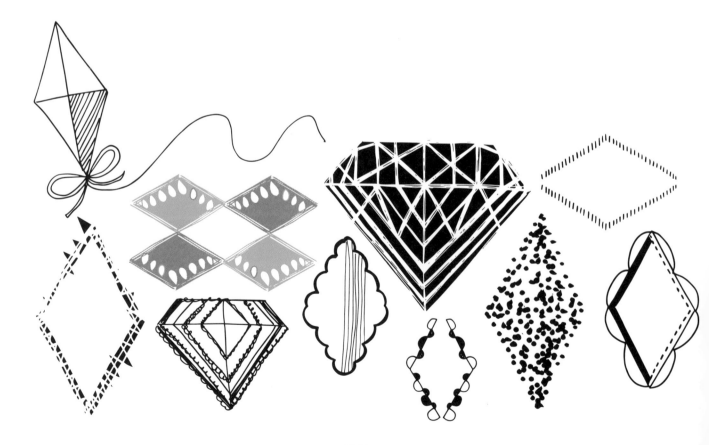

DRAW 20
DIAMONDS

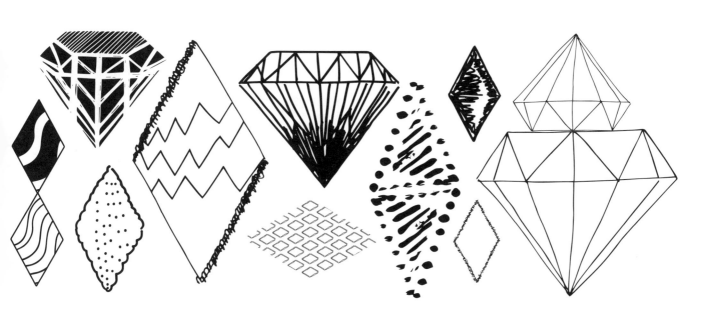

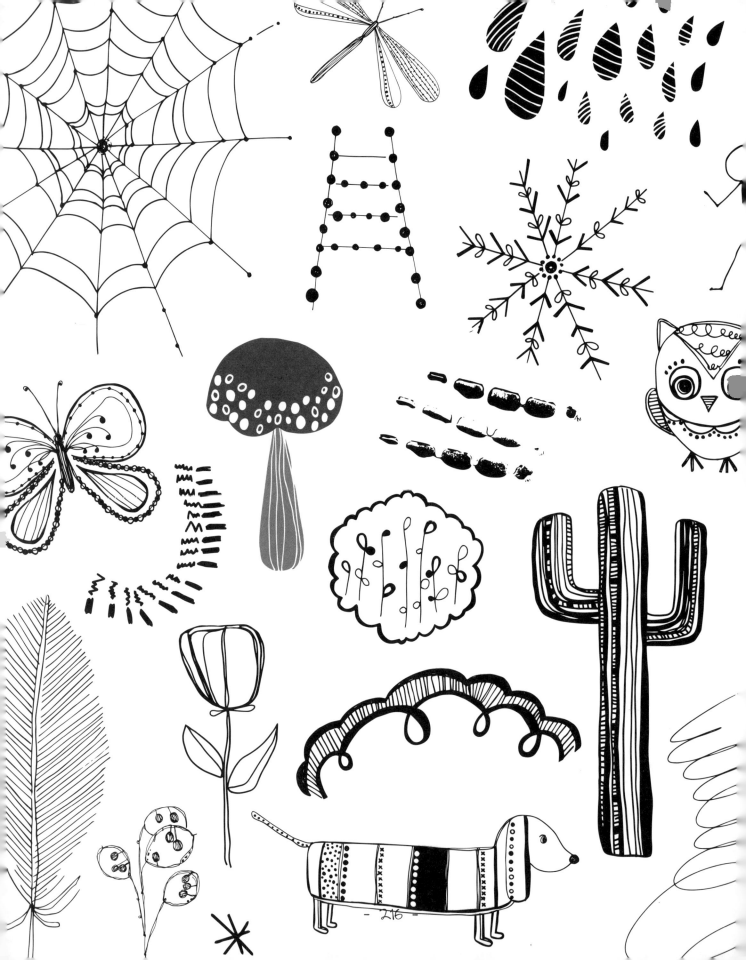

DRAW 20
doodles

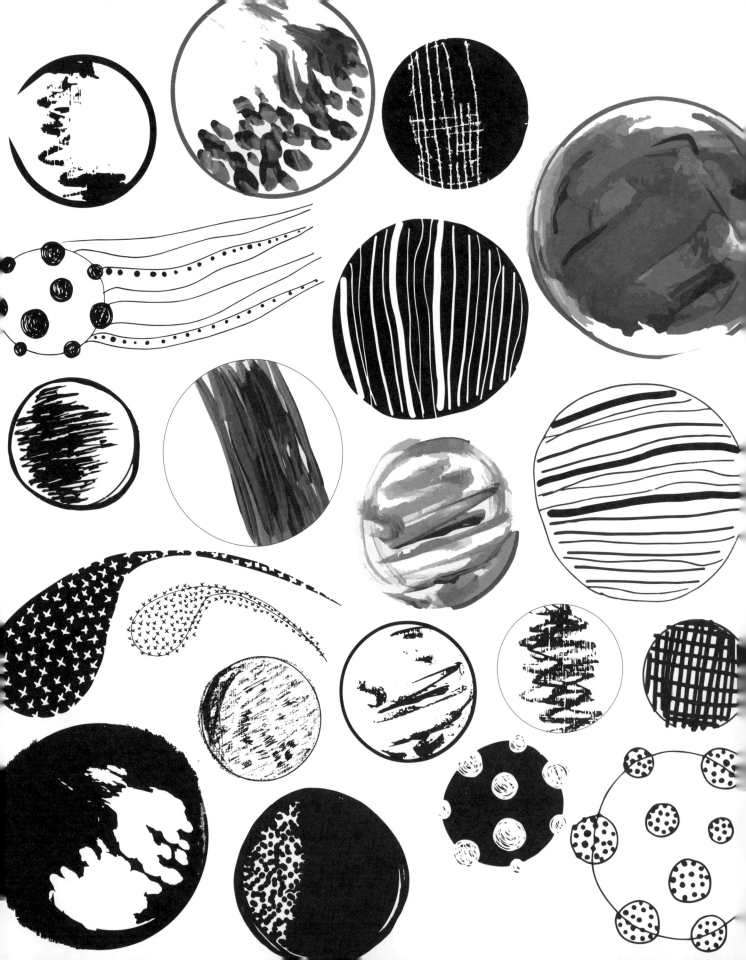

DRAW 20
PLANETS & COMETS

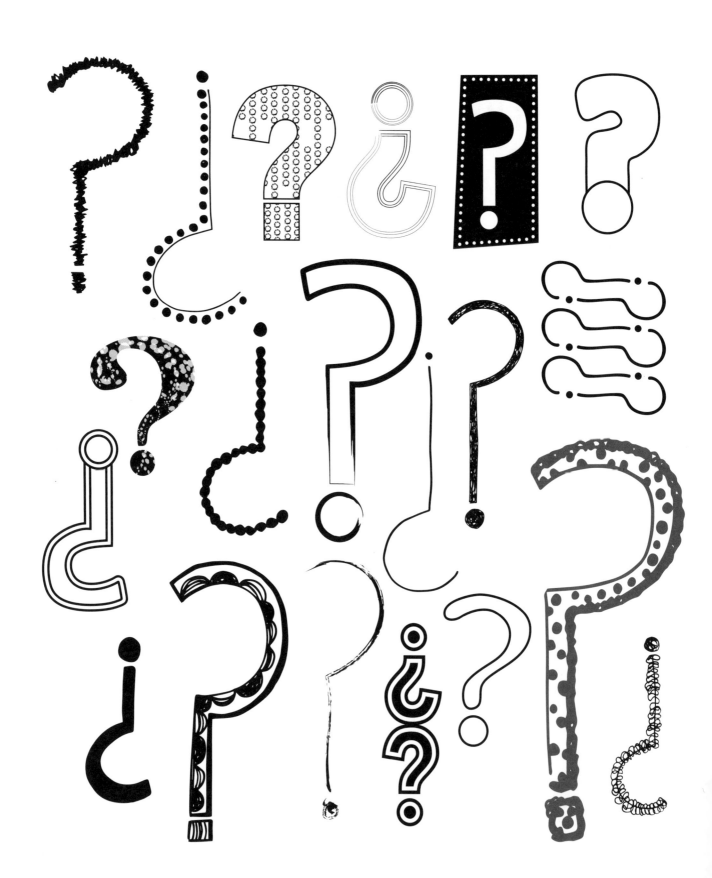

DRAW 20
Question Marks

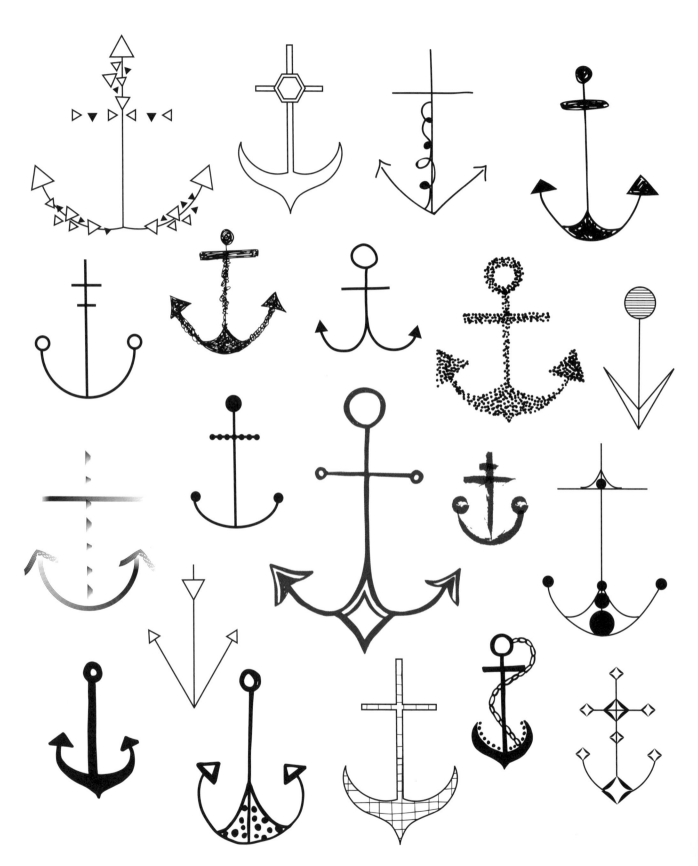

DRAW 20
Anchors

Inspiring | Educating | Creating | Entertaining

Brimming with creative inspiration, how-to projects, and useful information to enrich your everyday life, Quarto Knows is a favorite destination for those pursuing their interests and passions. Visit our site and dig deeper with our books into your area of interest: Quarto Creates, Quarto Cooks, Quarto Homes, Quarto Lives, Quarto Drives, Quarto Explores, Quarto Gifts, or Quarto Kids.

© 2014, 2015 by Quarry Books
Illustrations © 2014 Rachael Taylor, © 2015 Trina Dalziel, James Gulliver Hancock

This edition published in 2021 by Chartwell Books, an imprint of The Quarto Group
142 West 36th Street, 4th Floor
New York, NY 10018 USA
T (212) 779-4972 F (212) 779-6058
www.QuartoKnows.com

Contains content originally published in 2014 as *20 Ways to Draw a Doodle* and in 2015 as *20 Ways to Draw a Jellyfish* and *20 Ways to Draw a Bike* by Quarry Books, an imprint of The Quarto Group, 100 Cummings Center Suite 265D, Beverly, MA 01915, USA.

10 9 8 7 6 5 4 3 2 1

Chartwell titles are also available at discount for retail, wholesale, promotional, and bulk purchase. For details, contact the Special Sales Manager by email at specialsales@quarto.com or by mail at The Quarto Group, Attn: Special Sales Manager, 100 Cummings Center Suite 265D, Beverly, MA 01915, USA.

ISBN: 978-0-7858-3949-1

Publisher: Rage Kindelsperger
Creative Director: Laura Drew
Managing Editor: Cara Donaldson
Cover Design: Kim Winscher
Interior Design: Debbie Berne
Illustrations: Trina Dalziel, James Gulliver Hancock, and Rachael Taylor

Printed in China